T0168525

SAINTS, STATUES, AND STORIES

THE SOUTHWEST CENTER SERIES

Joseph C. Wilder, Editor

Saints, Statues, and Stories

A FOLKLORIST LOOKS AT THE RELIGIOUS ART OF SONORA

⌒

JAMES S. GRIFFITH

With Research Associate Francisco Javier Manzo Taylor

THE UNIVERSITY OF
ARIZONA PRESS

TUCSON

The University of Arizona Press
www.uapress.arizona.edu

© 2019 by The Arizona Board of Regents
All rights reserved. Published 2019

ISBN-13: 978-0-8165-3961-1 (paper)

Cover design by Leigh McDonald
Cover photograph by James S. Griffith

Library of Congress Cataloging-in-Publication Data are available at the Library
of Congress.

Printed in the United States of America
♾ This paper meets the requirements of ANSI/NISO Z39.48-1992 (Permanence
of Paper).

CONTENTS

Acknowledgments *vii*

Introduction 3
1. Setting the Stage 13
2. Roadside Sonora 41
3. Sonoran Artists of the Twentieth and
 Twenty-First Centuries 53
4. Fiestas 65
5. Saints and Miracles 77
6. Religious Art and Its Meaning in the Community 88
7. Memories of la Persecución 99
 Afterword 115

Appendix A. Verbal Religious Art *119*
Appendix B. Sacred Personages Mentioned in
the Text, with Their Feast Days *121*
Appendix C. Sonoran Legends of Saints Saving
Their Villages from Attack *133*
References *147*
Index *155*

ACKNOWLEDGMENTS

Any study of this scope and duration must of necessity reflect the hard work and willing assistance of many people, and this book is no exception. First and foremost, I am indebted to my research associate, Francisco Javier Manzo Taylor, known to all as Paco Manzo. Paco was born in Guaymas and has deep family roots in Sonoran history. His paternal grandfather was three-star general Francisco Manzo Robles, who served under General Álvaro Obregón in the Mexican Revolution. His maternal great-grandfather, the printer Douglas Alexander Taylor, arrived in Guaymas in 1880. The Taylors have been deeply involved in the commercial and social life of that important port city ever since.

Paco is an affable and gregarious man, with widespread acquaintance throughout Sonora. He holds degrees in law from the University of Sonora and the Universidad Nacional Autónoma de México. He currently resides in Puerto Peñasco (Rocky Point) and holds the position of Sonoran notario publico no. 26. Early on, he worked for the Museum of the University of Sonora and is an enthusiastic and well-published scholar of Sonoran history and archaeology.

Paco Manzo holding a statue of the Santo Niño, Opodepe (July 5, 1999).

For this project Paco accompanied me on as many field trips as he could, interviewing, suggesting ideas, and generally "shortening the road" with his inexhaustible supply of stories about the personalities of Sonora, past and present. He is the ideal traveling companion. In addition, he supplied me with introductions, books, clippings, literary references, knowledge, and ideas. In fact, Paco Manzo made this study possible.

Many others contributed greatly to the project. The Southwest Center of the University of Arizona generously provided funds that made much of the field research possible. Its director, Joseph C. Wilder, gave us constant interest and encouragement.

Others whose help was invaluable include the late Bernard "Bunny" Fontana who was my mentor, neighbor, traveling companion, and friend for almost sixty years; Alfredo Gonzales, traveling companion and source of ideas; and Jesús García, Sonoran botanist and traveling companion.

Occasional field companions included Father Charles Polzer, SJ, of Tucson; Father Thomas Steele, SJ, and Charlie Carrillo, both of Santa Fe; and Meg Glaser of Elko, Nevada. Sonorans who joined us in the field included arquitecto Joaquín Rodríguez,

Padre Principio Celaya, Padre Guillermo Coronado, Mario Munguía, José Rómulo Felix, and Director Francisco Borbón of the Casa Cultural Indígena, San Pedro, Río Mayo.

Among the people whom I interviewed and photographed in Sonora, I must thank doña Etelnidora Gil of Álamos, "Ropy" of Colonia Batuc, and especially the Contreras family of Puerto Peñasco.

Ana María Alvarado of Tucson shared with me the prayer to Santa Barbara in appendix B.

The santero Charlie Carrillo kindly allowed me to retell the story of how his uncle fell into the Río Grande and was rescued by San Antonio.

The late Dr. Robert Quinn introduced me to the joys of art history and the beauties of the Mexican baroque style. Should we end up in the same place, I look forward to discussing this book with him.

Father Gregory Adolf of Sierra Vista kindly read the manuscript with an eye to formal Catholic belief and procedure, as well as Church history, and offered much welcome advice. He also gave me the two evangelical tracts, mentioned in chapter 6.

My wife, Loma, accompanied me on many trips and served as critic, editor, and source of ideas throughout. Our daughter, Kelly, read and commented thoughtfully on the manuscript, serving as "the lady from Philadelphia" by delivering vital injections of common sense.

The folks at Parkinson Wellness Recovery and Dr. Cynthia Reed helped get me into good enough shape to write this book at all. My heartfelt thanks to all of you.

Although most of the photographs in this book are mine, I am indebted to Sra. Myrora Moreno Corona of Puerto

Peñasco for the excellent pictures of the Virgin of the Rosary that appear in chapter 7 and to Loma Griffith, who took the photograph of pilgrims with San Francisco in chapter 4. The Arizona State Museum graciously allowed me to use Helga Teiwes's image of the disrobed San Francisco Javier in chapter 1. David Burkhalter sorted through my thousands of field slides, organizing them and selecting the most significant ones for digitization, a job I could not have done better.

I owe an incalculable debt to the *cronistas* of Sonora. These men and women are paid a stipend by the state government to collect and publish details of the history, foodways, religious observances, and folklore of their home communities. Without their work, which has been collected and published in topical volumes by the state of Sonora, this study would be poorer indeed.

Finally, the people of Sonora opened their doors and churches to us, sharing their wonderful stories and allowing us to photograph their beloved images. Their generosity is mentioned and their presence felt throughout this, their book. It is dedicated to them.

SAINTS, STATUES, AND STORIES

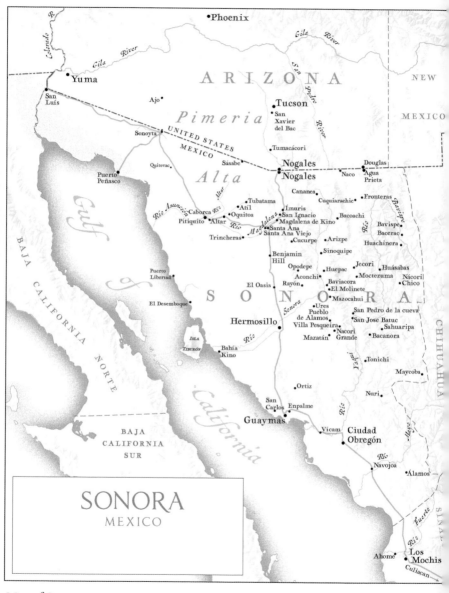

Map of Sonora

INTRODUCTION

Even the most casual driver along the roads and highways of the Mexican state of Sonora cannot help noticing the physical presence of Catholic religious piety. Crosses, chapels, and even murals stand by the roadside, and every town and village has at least one church. If you enter one of the churches, you will find pictures and statues of saints and members of the Holy Family, often adorned with handmade clothing and accompanied by ribbons, candles, and other offerings. If you watch the people in the church, you might find them speaking to, touching, or caressing those images. If you visit with those same folks, you may well hear stories concerning the interactions between the images, the personages they represent, and the community of the faithful. This book is about those interactions, and the following three narratives should help introduce it and provide many of its themes.

But first a word about folklore. The title tells us that this book, although it concerns art, was written by a folklorist—a person who studies the living traditions of *communities*. (A community is any group of people who share some characteristic that causes them to identify with one another. This may be based on shared ethnicity, occupation, location, or almost

anything else.) It may be as small as two or three people, or as large as several thousand. In this study the community consists of Catholics in the state of Sonora.

Although folklorists use history, we are not historians; finding out "what really happened" is not the sole aim of our research. When I know something about the history of a statue or an event, I report it, but to a great extent I recount legends, which folkorists define as narratives told as truth within a community. Once when I told a Sonoran historian that I had collected more than twenty-five origin legends for a certain shrine in Tucson, he had two questions: "Why are all those people lying to you?" and "Why did you write the lies down?" The answers are that they were telling the truth as they had learned it, and that paying attention to different versions of what happened is a good way of understanding the community-held values of the narrators. In this particular case, something important had clearly happened at that shrine, but the event was so far in the past that its details had been lost.

Nor am I an art historian; I try to go beyond the art and the artists to concentrate on the communities who produce and use the art. Art is an aspect of human culture, working within its specific culture in a number of ways. Like any item of culture, it can be described from several viewpoints—what it looks like, how communities use it, and the various levels of meaning assigned to it by its user community.

Art is difficult to define on a cross-cultural basis. Within Western cultural tradition, the art historian Erwin Panofsky defined a work of art as "a man-made object demanding to be experienced aesthetically" (Panofsky 1955, 14). Concepts of beauty vary from culture to culture, however, and many of

the responses to religious art I have found in the course of this research have more to do with the use or meaning of the art than with its appearance.

Now for the stories.

At some time around 1850, a mixed group of Seri, Papago, and Yaqui Indians was attacking the village of San Antonio de Oquitoa in Sonora's Altar Valley, about fifty miles south of the present-day international border. The Mexican villagers were defending the strongest building in town: the old mission church, a long, narrow adobe building standing on a hill above the rest of the village, which is in the floodplain of the Río Altar. (Defense had probably been in the minds of the original Jesuit builders when they raised the building in the mid-eighteenth century, and this was not the first time such structures on the far northern frontier had been so used.) Now, however, things

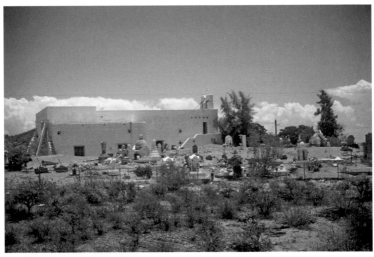

The mission church of San Antonio de Oquitoa, surrounded by its cemetery, stands on its hill above the Río Altar (April 10, 1979).

were looking desperate. The enemy kept attacking, and the defenders were almost out of ammunition. The next onslaught might be successful. Yet, the attackers were suddenly in full flight for no visible reason. The villagers were saved and doubtless sent up prayers of thanksgiving for that fact. But the question remained: Why this sudden retreat almost on the brink of victory?

The answer appeared long afterward, when villagers were able to question a man who had been one of the attackers. They had fled, he told them, when they saw the relief column approaching. What relief column? As far as anyone knew, no aid had ever arrived at Oquitoa at the time of the battle. The relief column, he replied, led by the bald-headed officer wearing a blue cloak. Then the villagers understood: they had been rescued by their patron saint, San Antonio, tonsured and clad in Franciscan blue. Or, as one Sonoran standing in the church a few years ago put it to a group of American tourists with a backward jerk of his head, "It was that guy, over the altar." And there in a niche was the eighteenth-century statue of Saint Anthony, just has he had stood for more than two hundred years.

The statue is about one foot tall and depicts the standing saint, tonsured and holding the baby Jesus. He does not put equal weight on each foot, but rather assumes the contrapposto so beloved of Renaissance and baroque artists: most of the weight on one foot, with the other leg slightly bent, setting the entire body into a graceful curve that suggests the beginning of yet more movement. This baroque sense of graceful implied movement tells us that that the statue was probably created at some time in the seventeenth or eighteenth century.

This legend of a saint saving his or her village from outside attackers has at least ten parallels in Sonora's former mission communities. While the details vary from site to site, the general narrative remains the same: when a group of hostile nonbelievers attacks the village, the patron saint of the church (and therefore of the village) foils them, usually through some sort of an illusion. These legends are discussed in greater length in appendix C.

For our next story we move several hundred miles south and inland to the mission community of Nácori Grande, in the foothills east of Hermosillo, the state capital. Above the main altar of the small church is a tiny (perhaps six inches tall) statue of the Virgin Mary. It represents the manifestation of Mary called La Virgen de los Remedios (The Virgin of the Remedies). She stands on a large crescent moon, and her dress stands stiffly out to both sides, giving her the appearance of an equilateral triangle. According to local oral history, this statue was originally intended for the much larger Jesuit mission community of Mátape, now known as Villa Pesqueira. When the statue was being carried through Nácori Grande on its way to its final destination, however, the mule carrying it balked in the middle of a *nopalera* (prickly pear cactus field) and would not continue. This was taken as a sign that the Virgin, working through her statue, indicated her desire to stay in Nácori. A kind of compromise was reached, however, by which the statue, while it resides in Nácori to this day, is carried to Mátape every year in procession for a *visita*, or visit, which lasts from July until September 10, when La Virgen is escorted back home.

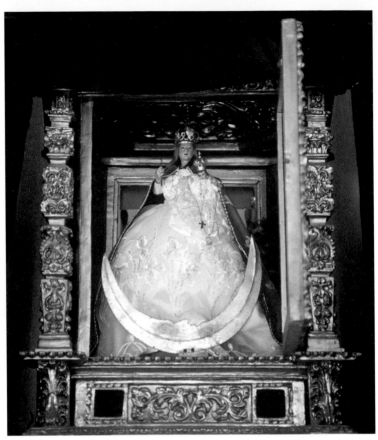

The statue of La Virgen de los Remedios over the main altar in Nácori Grande. Her baroque processional case, with its visible holes for carrying, was opened for the photograph in order to remove the reflective glass door (February 16, 2002).

For our final introductory story, we move to the town of Aconchi on the Río Sonora, where the mission church once contained a life-sized crucifix with a black corpus, known both as Nuestro Señor de Esquipulas (Our Lord of Esquipulas, a Guatemalan devotion) and El Cristo Negro de Aconchi

(The Black Christ of Aconchi; Griffith 1995, 87–108). On April 5, 1935, a group of dedicated enforcers of the socialist state government's anticlerical policies entered the church, removed all the religious images, and loaded them in a truck to be taken away and destroyed. When the load fell off the truck on a mountain road, however, the *quemasantos* (saint burners, as such activists were called at the time) decided to have their bonfire on the spot. The larger statues were cut up, the whole lot was put to the torch, and the quemasantos left the scene. A while later, Jesús Tánori Contreras, a farmer from the nearby town of La Labor, north of Mazocahui, saw the fire, grabbed a stick, and raked out the partly burned head of the Black Christ. He carried it to his sister Julia, who placed it on her home altar and began holding regular fiestas in its honor. And there it remained until the early 2000s, when doña Julia Tánori Dórame moved to the coast, taking the precious head with her. After the political situation in Sonora quieted down, the people of Aconchi ordered a substitute Black Christ, which now resides over the main altar (Encinas Blanco 2008, 96; Griffith and Manzo 2007, 84). I discuss much more of the quemasantos and the local resistance to their destructive activities in chapter 7.

Themes like these—a saint coming out of the church and protecting his or her village, a statue having a say in where it is to reside and paying social calls to other communities, and a beloved image being saved from the quemasantos or otherwise rescued from destruction and then being revered on a private altar—are common ones throughout Sonora. What a folklorist sees in these narrative themes, which form the core of the book, are patterns of communally held beliefs and values.

The head of the Black Christ of Aconchi, inside the box in which it used to rest on doña Julia Tánori Dórame's altar in La Labor (July 4, 1999).

To investigate and interpret these patterns, I have to touch on several disparate subjects: the geography and history of Sonora, the role of religious art in both official and Sonoran folk Catholicism, the production of that art over the years, what we know of the artists, and the role of religious fiestas—events in which the images play key roles. I introduce and augment these topics with descriptions of my field encounters with the art and its narratives, and with occasional forays into other aspects of local traditional culture.

While I have been photographing Sonora's religious art and collecting the stories and legends concerning it since the mid-1960s, at first this was merely part of my attempt to familiarize myself with Sonora. In 1998 I became more systematic and set out to visit and photograph as much of the art as

possible, in churches and chapels and along the roadside. At the same time, I began to read about the subject, relying on books and clippings, many of which were provided by my research associate, Francisco "Paco" Manzo. This fieldwork has continued into the twenty-first century, though health and mobility issues, as well as changing conditions in Sonora, have more recently curtailed my travels.

In the field, I would travel whenever possible with a companion. If Manzo, a hard-working Sonoran attorney, was not available, I would invite a friend who was bilingual or who knew aspects of the region better than I. Outstanding among these were the late Bernard "Bunny" Fontana of Tucson, Alfredo Gonzales of El Paso, and Jesús García of Magdalena, Sonora. We would visit a village, find the local sacristan, and request the keys to the usually locked church. Sacristans are appointed by the local priest and not only have the responsibility of preserving and protecting the churches and their contents but are usually important repositories of knowledge concerning local religious history, traditions, and images.

Having gained entry to the building, we would examine and document the art inside. While I did the photography, my bilingual companion chatted with the sacristan and anyone else present. As these on-the-spot conversations were informal, they were not taped, nor were informants' names requested. These conversations frequently concerned the image just before us, however, adding an extra degree of authority and immediacy to the narrative. Such was the case when the sacristana of Santa Ana Viejo told me how the Santo Niño de Atocha (Holy Child of Atocha) "right here" rescued a little boy who was lost in the desert near Highway 15—a story I retell in chapter 5.

To round out the visit, after leaving the church, we would drive through the village, documenting any other material of interest that we might see. In the evenings we would discuss the day, and I would write up our experiences and observations.

Beyond the data they collected, my Mexican companions contributed something of equal importance to my education: they taught me to travel like a Mexican, or, more specifically, like a Sonoran. We constantly "shortened the road" by enjoying what it had to offer in the way of local foods and products, turning what might have been a rigorous journey into a happy graze. For instance, we would never pass through Ímuris without stopping for quesadillas, a famous specialty made from local cheese. When we saw a hand-lettered sign at a ranch entrance saying *se vende queso* (cheese for sale), we would often investigate and sample. Sonora's roads and highways are dotted with small restaurants, produce stands, and craft workshops. By stopping, buying, eating, and chatting, I gained a much better understanding of the region.

Let's begin with a brief description of Sonoran geography and then look at how some of the art got to be where it is.

Chapter 1 _____

SETTING THE STAGE

The Mexican state of Sonora lies directly south of Arizona. Its western border is the Gulf of California, and from there, after a wide coastal plain in the Upper Sonoran Desert vegetation zone, the land rises in increasingly tall and rugged north-south mountain ranges to the Sierra Madre Occidental and the Chihuahua border. These ranges are separated by deep valleys through which flow rivers that eventually turn west and flow into the Gulf (West 1993, 1–9). These valleys have historically served as natural highways. Because of this topography, east-west travel has always been difficult. In recent years several east-west highways have been carved through the ranges, opening up previously inaccessible regions of the state to casual automobile traffic. Nevertheless, when starting from the U.S. border, it is often easiest to drive east or west along one of the comparatively straight paved highways on either side of the "line," and then head south along one of the older valley routes.

Sonora has always been somewhat isolated from the rest of Mexico. As José Vasconcelos, minister of culture during the Mexican Revolution, is reported to have said, "Sonora es donde termina la civilización y empieza le carne asada"

The valley of the Río Sonora, looking east toward Sinoquipe. Where there is water, there will be people (February 28, 2006).

Typical Sonoran Desert view: the Altar Valley, looking west toward Tubutama. The Sonoran Desert, dry for most of the year, springs into dense leaf following a good rain (February 10, 1998).

(Sonora is where civilization ends and grilled steak begins). Until the twentieth-century construction of dams on the rivers and the introduction of deep drilling, agriculture was possible only in the river valleys, while most of the rest of the state was given over to cattle raising. As if to emphasize this, we found a localized version of San Isidro Labrador (Saint Isidore the Husbandman) in Huásabas on the Río Bavispe. The saint, who is usually shown wearing high boots and an eighteenth-century laborer's smock, is here dressed as a Sonoran farmer in locally made straw hat, western shirt, jeans, and *tewas*, or Sonora-style boots. To top it off, his plow is pulled by white-faced cattle.

San Isidro Labrador statue in a family yard nicho in Huásabas. He is dressed as a Sonoran farmer. The identity of the other individuals was not explained (May 21, 2005).

Today Sonoran traditional culture extends well beyond current political boundaries. Before the Spaniards arrived, the population was centered in the valleys, where people were able to irrigate and grow crops. Near the coast and in the dry country to the north and east lived seminomadic people like the Seris and Apaches, who followed the seasonally changing availability of food. When Father Eusebio Francisco Kino, SJ, rode west from the Ópata mission of Cucurpe in 1687, he entered a region called the Pimería Alta, the land of the Upper Pimas, the people who call themselves O'odham. In modern-day terms, this region stretched from the Gila River south to Magdalena, and from the San Pedro and Santa Cruz Rivers to the desert west of Ajo. One region in Kino's day, it is now split by the U.S.-Mexico border (Griffith 1992, xvi–xvii). Kino and his successors founded missions and brought religious art to villages in what is now Arizona, and our discussion of art includes San Xavier and Tumacácori. Furthermore, the seventeenth- and eighteenth-century Catholicism the missionaries and others introduced still prevails, not only in Sonora, but throughout the Borderlands. For that reason I have drawn examples for the contemporary beliefs I discuss from Arizona and beyond, as well as from Sonora.

※

Christian religious art entered Sonora with Jesuit missionaries who started moving north from Sinaloa in the early seventeenth century. From their beginning on the Mayo (1614)

and Yaqui (1621) Rivers, first Jesuit and later Franciscan missionaries preached, taught, introduced Old World crops and customs, and built churches in Native villages. By the early nineteenth century, missions were scattered all over Sonora and into what is now southern Arizona (Roca 1967, 6–11; Spicer 1962, 289–94). The missionaries considered religious art essential to their efforts. In the first place, one could not have a church and say Mass without a crucifix, preferably large and easily visible. Furthermore, a church needs a patron saint, whose image should be available to the faithful as a visible reminder of his or her identity. The patron saint is seen as the protector of the church and its community and is frequently called on in times of need, as was San Antonio when Oquitoa came under attack.

The crucifix at Átil, locally believed to have been brought there by Father Kino. It was restored in the late twentieth century by Pedro Calles (November 1, 2003).

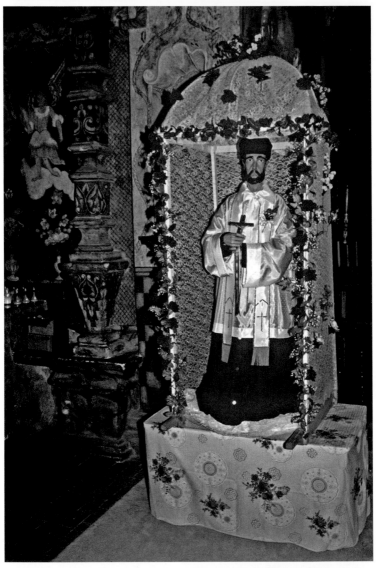

San Francisco Javier, patron saint at Bac, south of Tucson, in front of the altar at his feast day celebration (December 5, 1998).

In addition, the art provided an important teaching tool. When Father Garcés accompanied Juan Bautista de Anza on his California expedition in 1795, he took with him a two-sided painting, with a doomed soul in torment on one side and the Blessed Virgin Mary on the other. This he used when explaining the new religion to the unconverted peoples whom he met on his way (Engelhardt 1899, 90–91, 99). Remarkably, this painting is still with us, having been given by Garcés to a Spanish officer in the Tucson presidio, and passed on in that officer's family until the present day.

In 1965, a wall-cleaning crew washing the interior walls of the Franciscan mission church at Pitiquito with modern detergent uncovered a large number of murals that had previously been hidden beneath layers of whitewash. These included large depictions of a skeleton, the Devil, and the Virgin of the Apocalypse, along with the symbols of the four evangelists, a hand holding scales, and a reference to the terrifying handwriting on the wall that predicted the end of Belshazzar's life and kingdom (Daniel 5:25–28). While this discovery caused fear and consternation at the time, the paintings are now believed to have been created between 1783 and 1792 for use by missionaries to instruct the neophytes in the basics of Catholic doctrine (Lizárraga García 1996, 202; Scheutz-Miller 2000, 795–800). A few years ago, I was fortunate to sit in the Pitiquito mission church with a group of American tourists while the local priest, speaking through an interpreter, used the murals to present us with a truncated version of the Doctrina, just as a Franciscan missionary, also through an interpreter, might have done with his neophytes two hundred years ago. It took a little less than an hour and was one of those "time-machine"

experiences that occasionally make my travels in Mexico so exciting and wonderful.

Another didactic technique, popular in New Spain since the 1520s, was the use of religious drama to illustrate important Christian narratives (Spicer 1962, 295–96). Such dramas often incorporated music, dance, processions, dialogue, and the use of statues to represent important sacred characters. For instance, a Holy Week ceremony might involve the capture, persecution, and Crucifixion of Jesus by masked, evil *fariseos*, or Pharisees, followed by a mourning procession in which the

The didactic murals of the Virgin of the Apocalypse and the skeleton in the nave at Pitiquito (April 8, 2002).

statue of Christ is removed from the cross, placed in a bier, and carried around the plaza, accompanied by a statue of His Sorrowing Mother. After dawn, Christ is discovered to be risen, and a triumphal procession signals the beginning of the Easter fiesta.

In addition to a life-sized crucifix, often with hinged shoulders on the corpus to allow it to be placed in a bier after the Crucifixion, such an Easter ceremony could also involve several life-sized statues, including a Sorrowing Virgin; Saint John the Evangelist, who was present at the Crucifixion; and sometimes Saint Mary Magdalen, who discovered the empty tomb.

Here is an example of how such statues can be used dramatically. In the Mayo village of La Florida near Ahome on the Río Fuerte just over the border from Sonora, people carrying the statue of Mary Magdalen go to the place where Jesus had lain in state after the Crucifixion. Finding the tomb empty, they return to tell the news to the statue of the Sorrowing Virgin, whose bearers say "I don't believe you. Juan, run and see if it's true." (It was explained to me that this disbelief was because Magdalen had a dubious reputation.) The bearers of San Juan Evangelista (Saint John the Evangelist, the "Beloved Apostle" of Christ) then run to the empty tomb and back, reporting, "Yes, Madre Purísima, it's true."

These Easter ceremonies continue in many of Sonora's former mission communities, often in attenuated form (Griffith 1983, 773–76), but the best known and most elaborate are practiced by Yaquis and Mayos in both Sonora and Arizona. Here the ceremony lasts the full forty days of Lent, with tension slowly building between the forces of good and evil.

The fariseos, who are also ritual clowns, become increasingly bold and numerous, and the entire village is usually involved, participating in the drama as well as preparing and providing food for all comers and performing ritual dances at the ensuing fiesta.

A village's religious statues have a visible role in these processions and ceremonies. If a village were to lose one of its important processional images, it might well be replaced, even by "recycling" a less important one. For example, a statue of la Virgen Dolorosa (the Sorrowing Virgin) at the foot of the cross stands in the mission church at Pitiquito, where it is used in traditional Holy Week processions. Until recently it represented San Juan Evangelista. When a team of Mexican art restorers worked in Pitiquito in the early 2000s, they were told that the colonial Dolorosa statue had become unusable due to age and decay. Yet, the parishioners felt the need for a Dolorosa for their Good Friday processions, so San Juan was given new clothes and pressed into service. Visitors, including me, have remarked on la Dolorosa's strong, masculine face. Now we have an explanation.

This is not the only case we have found of image recycling, though it is the only one this well documented. The colonial-period statue that is currently venerated as Santa Lucía (Saint Lucy, patroness of eye troubles) stands in the mission church of San Ignacio de Cabórica, accompanied by *milagros* representing eyes. The statue shows a barefoot woman wearing what might pass in a baroque workshop for rags, with her long hair down around her shoulders. These details suggest that the image was originally intended to represent Santa María Magdalena (Saint Mary Magdalen) and was probably spirited away

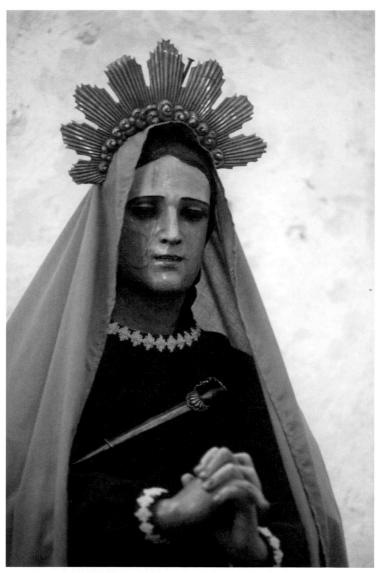

The Dolorosa in Pitiquito identified by parishioners as having been "recycled" from San Juan Evangelista (April 8, 2002).

The statue venerated as Santa Lucía in San Ignacio that may have started off as María Magdalena in the nearby town of that name (February 16, 2002).

from the church at nearby Magdalena at the time when its beloved statue of San Francisco was taken and burned by quemasantos. No explanation has been suggested for her transformation into Santa Lucía.

In a crypt below the church at Nácori Grande is a small, apparently colonial statue that was identified to Paco Manzo and me as la Magdalena. (Whenever possible, we would

obtain permission to examine the sculpture of a dressed statue, a practice which earned us the nickname among some of our friends of *los embichisantos*—"the saint-strippers" in Sonoran Spanish.) As we removed several layers of floor-length gowns from the tiny image, we began to notice a curious lump on its left shoulder. This lump turned out to be the Christ Child, carved out of the same block of wood as the rest of the statue. Thus we were able to identify the statue as a representation of La Virgen de Loreto (The Virgin of Loreto). Her devotion was important to the Jesuits, and the image probably arrived in Sonora before 1767, when that order was expelled from the Spanish Empire for political reasons and replaced in Sonora

"La Magdalena" in the basement at Nácori Grande as we first saw her (February 16, 2002).

"La Magdalena" in the basement of Nácori Grande revealed as a bulto de vestir *(statue to be dressed) of the Virgin of Loreto (February 16, 2002).*

by the Franciscans. We can only guess at what prompted the statue's reidentification.

※

Although most of the colonial religious art in Sonora was created elsewhere, as I explain below, there are a few wonderful exceptions—the plaster and stone sculpture that appears on church façades and in the churches themselves. This work was indeed created locally by trained artists. An outstanding and accessible example of this architectural sculpture is the façade of

the church of San Javier in Batuc, which was moved to the Plaza de los Tres Pueblos on Highway 15 in Hermosillo when Batuc was being covered by the waters of the newly constructed Novillo Dam in 1964. The highlight of the façade is the keystone over the portal, showing the Holy Trinity in high relief, surrounded by seven angels (Encinas Blanco 2016, 191–98). Other exciting pieces of locally made architectural sculpture include the plaster façade of the mission church at Tubutama (Officer, Scheutz-Miller, and Fontana 1996, 66–69) and the façade and retablos at San Xavier del Bac, executed in brick and plaster in the late eighteenth century (Fontana 2010, 25–44, 169–200).

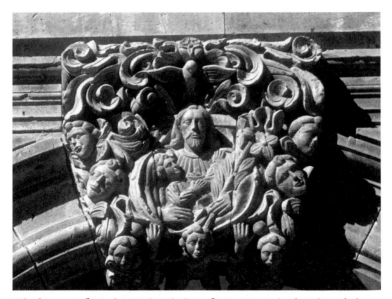

The keystone from the Jesuit Mission of Batuc, now in the Plaza de los Tres Pueblos on Highway 15 in Hermosillo. This magnificent example of eighteenth-century stone carving represents the Holy Trinity surrounded by angelic faces (February 1968).

An impressive amount of religious art from the colonial period, both painting and sculpture, was imported into Sonora, and much of it remains there to this day. Encountering it in situ is always an exciting experience. The bulk of it was created in the baroque workshops of Mexico City and Guadalajara by teams of professionals. A statue, for instance, would be carved by a *carpintero* and then handed over to a *yesero*, who would apply the base coat of gesso. A *pintor* provided the basic painting, while an *encarnador* was responsible for the *encarnación*—the delicate flesh tones, many of which still remain lovely after two hundred years. Finally, an *estofador* would finish the statue by applying *estofado*, or tooled gold-leaf floral ornament, to the statue's clothing. The same team process might well be applied to a painting, with the master roughing in the picture and finishing its important parts, and assistants finishing the rest.

In this study I give colonial painting less attention than it deserves for the following reasons. Many of the paintings still hanging in colonial churches are difficult to examine: they tend to be hung high, in dark rooms, and need cleaning to be made legible. In fact, the only such painting signed and dated that we identified is a 1799 Virgin of Guadalupe by the Mexico City painter José de Alcíbar. As it hangs in a poorly secured church, off the beaten path, I shall not give its location in order to protect it from looting, a practice I have followed in other cases of vulnerable religious art. Finally, the focus of this study is on the devotional uses of art, and except for paintings of the Virgin of Guadalupe (whose image is derived from

a painting), we have found few examples of such use. A rich store of colonial-era paintings awaits future investigators.

A few words concerning the aesthetic of baroque sculpture would be appropriate at this point. Baroque sculpture emphasizes realism, drama, and richness. Realism appears in the encarnación, or flesh tones, and in the flow of the robes. Drama is constantly implied by the arrested motion apparent in so many statues. The ever-present gold leaf, dark and vibrant colors, and painted designs on so many garments attest to the importance of richness of color, materials, and detail. The sort of gold patchwork on a dark brown background on Saint Lucy's statue in San Ignacio might be as close as a baroque estofador could bring himself to a representation of rags!

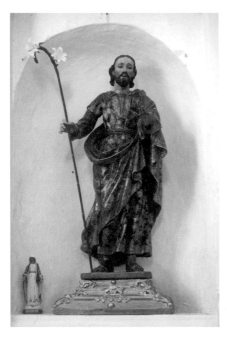

The statue of San José in Pitiquito, showing elaborate estofado (April 8, 2002).

Every piece of art that was destined for Sonora during co-lonial times had to be brought on trails over great distances from the workshops of central Mexico. While very small stat-ues might be carried in saddle bags, the life-sized ones had to come by pack mule. Some traveled as complete statues, but others were *bultos de vestir*—statues to be dressed. These con-sisted of finished head, hands, and torso that, upon arrival at their destination, would be placed on an armature and dressed. Cloth strips would reach from the shoulders to the hands, and the whole thing would be ready to stand in the church or be

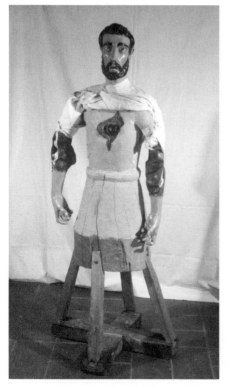

The eighteenth-century bulto de vestir of San Francisco Javier at Mission San Xavier del Bac. Photograph by Helga Teiwes, January 2007, courtesy Arizona State Museum, University of Arizona.

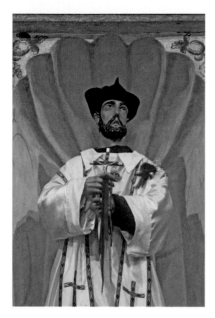

The fully dressed bulto de vestir of San Francisco Javier as he appears over the main altar in Mission San Xavier del Bac (September 27, 2003).

carried in a procession. Many of the Dolorosa images in Sonora's mission churches are of this type and are carried in Good Friday processions to this day. Bultos de vestir that may be familiar to many readers are the Dolorosa and the San Francisco Javier over the altars in Mission San Xavier del Bac, just south of present-day Tucson. They are not necessarily large statues; the tiny image of the Virgin of Loreto in Nácori Grande is a bulto de vestir.

Many such statues, like the San Francisco just mentioned, were not necessarily intended to stand alone but were created as parts of an elaborate carved and painted retablo, or altarpiece. Such retablos occupied the wall behind the altar, were usually covered with gold leaf, and could include columns, relief decorations, statues, and paintings. Although the San

Xavier retablo was carved in place from plaster, most were made of wood.

An elaborate wooden retablo would be broken into its component parts before shipping and reassembled at its destination. For example, there is a large baroque retablo, complete with seven big paintings and two statues, in the Jesuit mission of Javier del Vigge in Baja California. It was shipped from Mexico City for the dedication of the mission in 1759 and is probably older than that. It took thirty-two crates to transport by muleback (Quinn, n.d., 59; Vernon 2002, 28). Complex retablos still existing in Sonoran missions may be found in Arizpe, Moctezuma, and Tubutama. Many others, such as the one that used to be in Oquitoa, have succumbed to time and termites (Eckhart and Griffith 1975, 31–32).

Because after two centuries, there are few surviving missionary records of ordering and transporting specific statues and paintings, our search for information on how particular pieces of art arrived in colonial Sonora often takes us from the realm of documented history to that of legend. Legends are narratives that a community tells as true. They can at times fill in gaps in historical knowledge and provide answers when records do not exist and have been forgotten. Popular legends can migrate from place to place, however, so we often encounter similar stories that explain the presence of statues in different localities. Legends can also tell us much about the values and beliefs of the communities that preserve and retell them. Following is a pair of arrival legends that accompany two locally venerated colonial images.

The former mission community of Bácerac is on the east side of the Río Bavispe in far eastern Sonora, southeast of

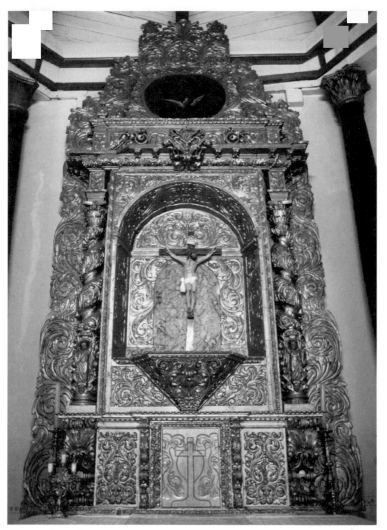

The small baroque retablo in the side chapel of the mission church at Moctezuma. A retablo like this could be broken into its component pieces and transported on muleback (April 17, 1974).

Agua Prieta. To the east of the river are the Sierra Madre Occidental and the Chihuahua border. In a glassed-in case in the nave of the mission church of Nuestra Señora de la Asunción (Our Lady of the Assumption) lies a statue of the entombed Christ, known locally as el Santo Entierro de Bácerac (the Holy Sepulcher of Bácerac). In 1887, a powerful earthquake, over 7 magnitude, struck nearby Bavispe, flattening its mission church and even knocking columns off the façade of Mission San Xavier del Bac, some 150 miles away in Arizona (McGarvin 1987). In Bácerac, about ten miles from the epicenter, the façade and the front two-thirds of the nave were destroyed, but the rear portion, with its three huge barrel vaults, held firm. These vaults protected both the much-beloved Santo Entierro de Bácerac and the patronal statue. It is locally considered a miracle that both survived.

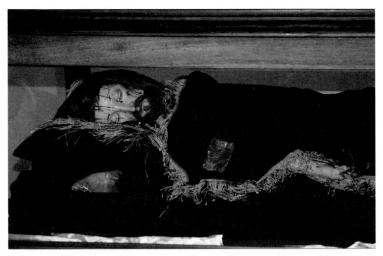

El Santo Entierro de Bácerac in his glassed-in case in the nave of the Bácerac church. The small plastic bags contain ex-votos (March 12, 2006).

El Santo Entierro de Bácerac is a life-sized corpus from a crucifix, with hinged shoulders so that it can be removed from its cross and placed in a bier. It appears to date from the eighteenth century. According to legend, the statue arrived in Bácerac in a crate on the back of a stray mule. (Legends concerning the miraculous arrivals of religious art on the backs of wandering and apparently divinely guided mules are not uncommon throughout Mexico, the most famous one being the arrival of the statue of the la Virgen de la Soledad [the Virgin of Solitude], patron of the city of Oaxaca.)

The Santo Entierro de Bácerac is an important object of petitions and pilgrimages, especially from people living in the mountains east of the river (Anonymous, n.d.). It is also the subject of a rare commercial engraving of a Sonoran image, an indication of its importance within its greater community (Griffith and Manzo Taylor 2007, 66–68). Although the engraving is unsigned, it, like the original statue, was probably created in either Mexico City or Guadalajara.

Far to the south lies the formerly rich mining city of Álamos, now a popular destination for American tourists and retirees. Just north of Álamos is the partially abandoned mining community of Aduana, the site of the first great silver strike in this mineral-rich region. It is also the home of the devotion to the Virgin of Balbanera and the site of a large annual pilgrimage and fiesta on November 21. When I first visited Aduana in the late 1960s, the fiesta was in full swing. Booths had been set up in the arroyos that cut through the remains of the town, and the church was crowded with pilgrims visiting the image of Nuestra Señora de Balbanera. This large heavily "restored" painting shows the Virgin and Child seated on a large prickly

pear cactus. The Balbanera devotion came from Spain, where the original statue is said to have been discovered concealed in an oak tree. The Sonoran legend has been adapted to the local landscape through the substitution of a prickly pear for the oak.

A small statue of the Virgin and Child stands in a wooden case in front of the altar, dwarfed and rendered inconspicuous by the larger painting. The statue is about one foot tall and appears to be of colonial origin. (It is further described and illustrated in chapter 7.) Indeed, it may be the very statue that, according to legend, was found in the prickly pear cactus. As if to reinforce the local discovery narrative, a cactus grows in one of the windows of the church that, at the proper time of day, casts a shadow resembling the silhouette of the statue. The devotion to Balbanera in Spain and Sonora is given a thorough treatment by Fontana (1983, 81–92).

❊

With the collapse of the mission program and the secularization of Sonora's missions in the early nineteenth century, the game changed. Religious art was no longer brought to the villages by missionaries but rather ordered by the secular parish priest, the people of the parish, or the owner of a private church or chapel. Hand-carved wooden sculptures became fewer, to be replaced by plaster statues. Unchanged was the fact that most of the art came from outside the region, in great part from Mexico, but occasionally still from Europe. Most of these images were mass produced of cast plaster and then

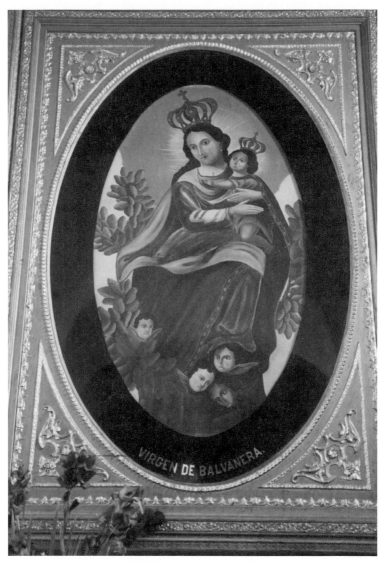

The heavily overpainted portrait of the Virgin of Balbanera in her church in Aduana (April 3, 2001).

hand painted. Not until the twentieth century did individual Sonoran artists come into our view.

Although little solid information concerns the art of this later period, we do have one documented example. In the private chapel at the Astiarazán family's Hacienda Cerro Pelón near Hermosillo is a statue of la Virgen de la Candelaria (the Virgin of Candlemas), which was ordered from Portugal by the family around 1900. Although the hacienda, which once employed three hundred people, has diminished greatly, the chapel is well maintained, and Mass is said there occasionally. This example must serve to represent the arrivals of many mass-produced statues purchased from Mexico and abroad from the late nineteenth century to the present day. Found throughout Sonora, they vastly outnumber the surviving colonial ones. Finally, there are the images not brought to Sonora but created there by local artists. These, mostly dating from the twentieth century, are discussed in chapter 3.

✻

During the nineteenth century, Mexico gained independence, became a republic, suffered through foreign invasions, lost territory, and underwent a series of revolutions and abrupt changes of government. The Catholic hierarchy became rich and powerful, controlling education, owning vast stretches of land, and moving in an increasingly authoritarian and elitist direction.

Through all this, although the nation retained a strong impulse toward centralization of power, the north, including Sonora, remained physically isolated and remote from some of

the national tumult. It remained largely Catholic, with strong devotions to locally popular images and a dwindling presence of priests in the more rural areas. Nonetheless, Sonora underwent its own changes. After the Gadsden Purchase of 1853, Sonora's northern fringe became a part of the United States, and then, in 1914, the state of Arizona. This led to an influx of American citizens. In the 1890s, with the end of the Apache Wars, many Sonorans started to come into Arizona, especially to work in the mines. The 1914 Mexican Revolution led to another Sonoran influx, and Mexican immigration continues to this day. This is why some of our artistic examples are in San Xavier del Bac, and much of the interpretive data in this book is based on interviews conducted in Arizona.

One of the biggest changes wrought after independence was the gradual reduction of the wealth and power of the Catholic Church. Although this process began in the 1870s with the Laws of Reform, it was not completed until the Constitution of 1917. After that, church land holdings were nationalized, religious schools and public religious ceremonies were forbidden, and the country was well on its way toward total secularization on a socialist model. The faithful fought back with all their strength and ability, and the ensuing period of armed conflict, called the Cristero Wars (after the *cristeros*, or "soldiers of Christ," who fought to maintain their religious practices) lasted officially into the late 1920s. Even in the 1930s, when things had quieted down in the most conflicted regions of Jalisco and Michoacán, the dedicatedly anticlerical socialist government of Sonora enforced a series of draconian laws that deeply disturbed many Catholics. In this *campaña desfanatizante* (defanatization campaign), priests were expelled, public worship was forbidden, and churches were

secularized. Quemasantos, who included soldiers, law officers, and radical school teachers, entered the churches and removed and destroyed all the images they could find in this effort to eradicate "superstition" and pave the way for secular socialism (Encinas Blanco 2008, 51–102; Vaughan 1997, 62–63).

Passions were high on both sides in this period of conflict, which is called *la persecución* (the persecution) by Sonoran Catholics and *la cristiada* (the time of the cristeros) by Sonoran historians. While the faithful tried to save their images, often at great personal risk, the quemasantos went about their task with equal intensity and enthusiasm. An illustration of this is the 1935 rumor that Rodolfo Elías Calles, governor of Sonora and son of former president Plutarco Elías Calles, wore a severed finger from the Magdalena statue of San Francisco on his watch chain (Pickens 1993, 64). Another account of the fate of this particular statue mentions that quemasantos danced in the Magdalena church when the saints were removed and destroyed. In our fieldwork and research, we encountered many stories from this time, the events of which were seared into the hearts and memories of the faithful.

Clearly, a large part of the Sonoran populace did not support the state government's anticlerical fervor, and today little remains of this traumatic era of history save still-vivid memories. These, along with anti-Catholic attitudes of some members of the political elite, seem to be all that is left of the religious suppression campaign. The abundance of roadside shrines, churches, and saints' day fiestas to be found throughout the state testifies to the continued persistence of Catholic beliefs in Sonora.

Chapter 2 _____

ROADSIDE SONORA

A drive through Sonora can provide a fine introduction to the importance of popular Catholicism today. From simple death memorial crosses to roadside chapels and religious murals, roadside religious art gives us the outer surface—the skin of the onion, if you will—of a complex series of traditional beliefs and practices. Much of the rest of this book is devoted to peeling away layers of that onion and moving toward the meaning of what can be observed.

Roadside religious art goes back a long way in Sonora. Alongside ancient trails in the desert, one can find piles and arrangements of rocks, often near mountain passes, arroyo crossings, and other places of potential danger. One can speculate that these in some way lessened the dangers of that particular part of the journey. As recently as the 1960s a large rock pile surmounted by a metal cross stood where the road to Tónichi forded the Río Yaqui. Passersby added a rock to the pile as a way of augmenting the request for protection that the shrine symbolized. At that time the only way for vehicles to cross the river was by means of a somewhat hazardous *panga*, or ferry barge attached to an overhead cable and pulled across

by the force of the current. Ford and panga have been replaced by a bridge, and I did not see the rock pile on a recent trip.

It has long been customary all over Mexico to place a cross, a rock pile, or some other memorial at the site of a roadside death (Griffith 2005, 233–48). The cross may bear the name and dates of the deceased and perhaps a bunch of artificial flowers placed by friends or family members. Traditionally such a memorial is a reminder to pray for the soul of the

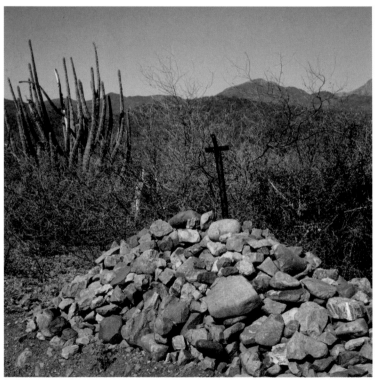

The rock pile shrine by the old ford of the Río Yaqui, near Tónichi. Now that the potentially dangerous ford has been replaced by a new bridge, I have been unable to locate the shrine (April 1966).

Door of a death marker capilla on the road between Magdalena and Cucurpe, showing that the deceased was a vaquero, or cowboy (February 28, 2006).

deceased. In the 1990s I documented 143 death markers at 123 locations on the 140 kilometers of Highway 15 between Santa Ana and Hermosillo (Griffith 2005, 243). Some death markers take the form of miniature chapels, or *capillas*. These may contain a religious image, the name and dates of the deceased, and often a photograph and an indication of his or her occupation. Even more than the crosses, they provide places for offerings of various kinds.

Not all roadside shrines and chapels are death memorials. Many were apparently erected as places of petitions, where travelers may stop and pray. Such capillas are common throughout Sonora, not only along well-traveled highways but on small

country roads. Although they may be dedicated to any of a multitude of saints, by far the most common images are Our Lady of Guadalupe and San Judas Tadeo (Saint Jude). Guadalupe, often referred to as the Queen of the Americas and the Mother of Mexicans, appears all over Mexico. As the philosopher Octavio Paz is said to have written, she and the National Lottery are the only things all Mexicans believe in. She belongs to everyone. A shrine on a mountain road near Moctezuma shows her protecting truck drivers and motorists from accidents. A much larger and more elaborate shrine on the dirt road between Empalme and Ortiz has given her the title of Mi Yaquesita [*sic*] (My Dear Yaqui Woman). The phrase is taken from the title of a regionally popular *cumbia*, but the shrine is well within traditional Yaqui territory.

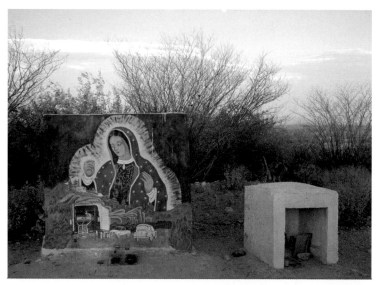

Guadalupe shrine on Highway 14, asking the Virgin's protection for motorists and truckers (May 21, 2005).

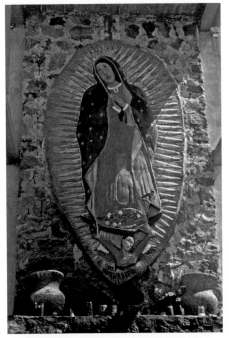

Large roadside Guadalupe shrine between Empalme and Ortiz, Sonora. The image appears to be of painted plaster. A barely visible inscription below the supporting angel reads "Mi Yaquesita" (March 12, 2000).

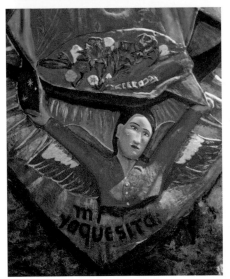

Detail of Guadalupe "Mi Yaquesita" shrine (March 12, 2000).

Judas Thaddeus was one of the twelve disciples of Christ and is venerated as the patron of impossible causes. He is usually shown dressed in green and wearing a huge religious medal, which some interpret as a coin. He also occasionally holds a carpenter's square. From the 1980s on, he became what one of my Sonoran friends called *el Santo de la moda* (the fashionable saint), with his image appearing everywhere.

In El Oasis, a wide spot on Highway 15 between Santa Ana and Hermosillo, with a few houses, a gas station, and a restaurant, is a large and beautiful chapel dedicated to Our Lady of Fátima. It was built in the early 1950s to house a statue ordered from Portugal and is currently looked after by the daughter of the original owner, who lives in the railway town of Carbó, about eight kilometers east of El Oasis. When she comes to the

San Judas and Guadalupe painted slabs between Magdalena and Cucurpe. The signature reads "Epifaneo Molina, Imuris, Son. 6-19-1987." The notice says, "Do not light candles near" (January 14, 2001).

Chapel to Our Lady of Fátima in El Oasis, being visited by motorists (June 11, 2000).

chapel to clean and maintain it, she collects any money left as offerings, which she considers belonging to the Virgin. This money she saves and uses to purchase menudo and other food to serve to all comers at the Virgin's fiesta on May 13. Mass at the chapel is usually part of this celebration. I have been told that this chapel is used by travelers, and especially *troqueros*, or truckers, many of whom regularly stop to pray for a safe journey (Griffith and Manzo 2006, 238–52).

The northbound roads and highways approaching the U.S. border are especially rich in shrines. Here, in addition to saints like Guadalupe and San Judas, one sees chapels dedicated to individuals not recognized by the Catholic Church but to whom many *narcotraficantes* (drug runners) turn for help. While driving southeast from Agua Prieta in the spring of 2006, I saw a number of these. Just below the border was a

small domed chapel dedicated to la Santa Muerte, a personification of Death, often shown as a robed skeleton holding a scythe in one hand and the terrestrial globe in the other. Inside, in front of her image, are offerings of fruit, money, cigarettes, and liquor. Hers is a relatively recent devotion, which has gained great popularity in both Mexico and the United States (Chesnut 2013).

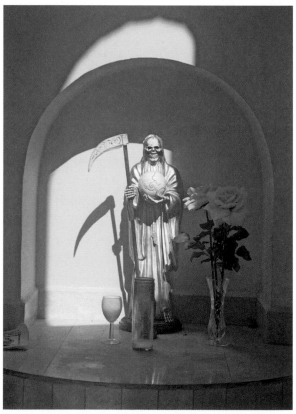

La Santa Muerte in her elaborate chapel on Highway 15, just south of Nogales, Sonora (October 4, 2003).

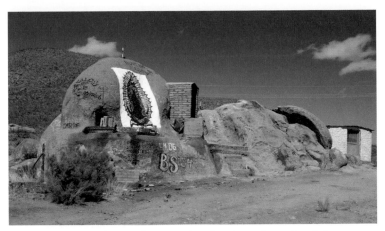

Large outcrop southeast of Agua Prieta bearing a huge Guadalupe painting and eight small Malverde chapels (March 11, 2006).

After the paved road swung east, there was a large stone outcrop bearing a huge painting of the Virgin of Guadalupe, flanked by eight small chapels dedicated to Jesús Malverde. A legendary social bandit, Malverde is believed to have operated out of Culiacán, Sinaloa, in the early twentieth century. Although his devotees may come from other walks of life, he is best known now as the patron saint of the drug trade (Griffith 2003, 85–89).

Shrines allegedly created by narcotraficantes may frequently come in clusters dedicated to several saints. Discussing one such grouping with Paco Manzo, I was told that "Malverde helps you get the job done, San Judas helps you find work, the Santo Niño de Atocha will help when you're in jail, and the Virgin of Guadalupe is everyone's Mother."

Along with secular graffiti just below the giant Guadalupe, a spray-painted statement declares in large letters

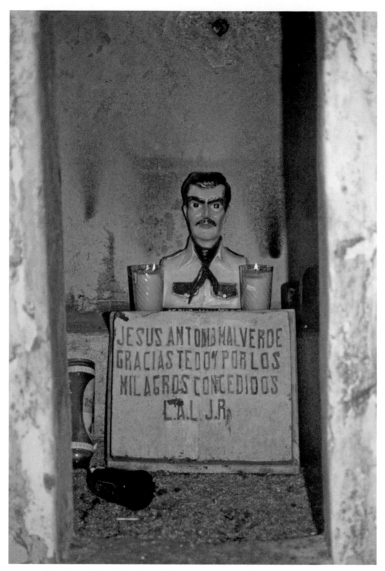

Bust of Malverde in his chapel in Barrio San Isidro, Magdalena. The inscription reads "Jesus Antonio Malverde, I give you thanks for the miracle you have granted me. L.A.L. J. R." (July 13, 2001).

"SI NO ERES DE MI RELIGION NO ME MOLESTES GRACIAS" (If you are not of my religion, don't bother me, thanks). Such statements of contested space are not uncommon at Sonoran roadside shrines (Griffith and Manzo 2006, 255–57). Although the most obvious use of the chapels is as places of prayer, it is not the only one. We have seen several vandalized and desecrated chapels, as well as a few chapels carrying signs like the one on the outcrop mentioned above, beseeching the visitor to respect the religion of others. A notable such inscription is addressed to the writer's *hermano separado* (separated brother). These sightings suggest that a real, if unintended, use of the chapels is as sites of religious contestation. Further evidence of this contestation between Catholics and fundamentalist Protestants may be found on the road that goes through western Chihuahua to Palomas, New Mexico. A road cut bears a painting of San Judas with the phrase "no existe" (he doesn't exist) spray painted below it.

Yet another possible use of roadside chapels came to light on February 13, 2000, at a Guadalupe chapel on Highway 2 between Sonoyta and Puerto Peñasco, when a fatal shooting occurred. Although the surviving victim claimed the motive had been robbery, I have heard speculation among law enforcement officers that what really happened was a drug deal gone wrong. After all, a roadside chapel would be a convenient and safe place for two strangers to "accidentally" meet. As one friend told me, the only reason to stop at such a chapel is *negocio* (business), and there are two kinds of business: *negocio espiritual y negocio en efectivo* (spiritual business and cash business). He suggested that this was a case of the latter (Griffith and Manzo Taylor 2006, 235).

Now let's move to the men and women who have created—and still create—the art that is the subject of this book. Some are well documented; most are anonymous or exist only as a signature on the corner of a painting. A few were prolific, while the majority of those whose names we know seem to have left only one or two works. So far, none is identified as having worked before 1900. All have left their mark in Sonora's churches, chapels, and roadsides. Interestingly, the first artists we could identify by name were women.

Chapter 3 _____

SONORAN ARTISTS OF THE TWENTIETH AND TWENTY-FIRST CENTURIES

The first Sonoran artist whom we know by name is señorita Beatriz Araiza, who was president of the Hijas de María society in Ures in 1918. She is mentioned on a plaque as having created the small statue of la Virgen Milagrosa that now stands in a niche in the nave of the Ures church. I have also heard of a woman living in Oquitoa around the 1930s or 1940s who is said to have created an altar out of the remains of the old retablo in the church and whittled the animals for the church's Nativity scene.

In the twentieth century, at least two artists who had trained in Mexico City arrived in Hermosillo and began teaching. Although none of their works have been identified, some of their women students produced religious art. Doña Josefina Ávila painted on both canvas and porcelain, while María Emilia Fontes Iniqui created religious paintings in the 1930s. Luz Aguilar Águila of Cananea became well known for her paintings of the Virgin of Guadalupe (Manzo Taylor, n.d.a). One such painting was commissioned by Bishop Juan Navarrete to be hung in the Santuario de Guadalupe in Hermosillo, where I photographed it in December 2000. We were later told that a priest had raffled it off to raise funds for his parish, and we are unaware of its

Statue of la Virgen Milagrosa, made in 1918 by Beatriz Araiza. The statue stands in the nave of the church in Ures (March 20, 1999).

whereabouts. It is not unusual for priests in Mexico to consider the art and objects in the churches they administer to be theirs to dispose of as they see fit. Much of the Mexican colonial religious art in American museums and private collections came onto the market in this way.

In contrast with some of these shadowy figures, don Pedro Calles was a well-documented and prolific sculptor whose works may be seen in many churches in and near the state capital, Hermosillo. Pedro Calles Encinas was born in the small inland village of San Pedro de la Cueva in 1914. Unfortunately, in 1916, the revolutionary general Francisco "Pancho" Villa was

Detail of the painting of the Virgin of Guadalupe by Luz Aguilar Águila as it hung in Hermosillo's Santuario de Guadalupe (December 16, 2000).

retreating eastward across the sierra after a disastrous attempt to invade Sonora. Equally unfortunately, the villagers of San Pedro, tired of constantly having their stock run off by every group of armed men who rode by, shot one of Villa's men. On hearing this, Villa flew into one of his famous rages and ordered that every male over the age of fifteen be shot. When the village priest begged for the life of a prominent citizen, Villa shot the priest as well (Naylor 1977).

Pedro Calles grew up an orphan in a village of orphans. As a young man he showed a talent for art. He married a school teacher from Ures, who paid his way through the prestigious Academia Nacional de Arte (formerly the Academia Real de Arte) in Mexico City, the institution where Diego Rivera received his training. Calles then concentrated on sculpture and studied for a time with the well-known sculptor Ignacio Asúnsolo. The younger man then returned to Sonora, settled in Hermosillo, and began his work as an independent artist. Specializing in religious sculpture, he augmented his income by filling all sorts of special commissions, ranging from restoring colonial statues to creating memorial plaques and building baroque furniture. Between 1943 and 1993 Calles produced more than four hundred religious statues, most of which remain in Sonoran churches and chapels (Calles Gonzáles 2003). His religious sculptures are realistic and iconographically correct. Although most of his work that I have seen consists of good, serviceable religious sculpture, a few of his life-sized pieces truly sing. Among these latter are *Señor de los Afligidos* (*Christ Resting on His Way up Calvary*) in a private chapel in Hermosillo and a Risen Christ in the church at Villa Pesqueira (Griffith and Manzo Taylor 2007, 40–42, 71–72).

San Isidro Labrador by Pedro Calles, in a hacienda chapel near Ures (April 20, 2002).

Detail of a life-sized statue of Santa Eduvigis by Pedro Calles, in the Coronado family chapel near Mátape (Villa Pesqueira) (October 26, 2002).

Unlike Calles, many Sonoran religious artists were self-taught. One of these, Felix Lucero, while serving as a soldier in France during World War I, found himself alone and wounded in No Man's Land. He promised that if he made it out alive, he would devote the rest of his life to religious works. When he arrived in Tucson years later, he camped under the old Congress Street bridge over the Santa Cruz River and started creating sculptures out of the sands of the dry river bed. During lunch hour, pedestrians would watch Lucero and throw him coins, providing him with some means of support. Around 1948 he cast versions of his statues in cement and placed them up on the west bank of the river, north of the bridge, where they would be safe from floods. Eventually, they were taken higher

Pieta by Felix Lucero in the Shrine of Saint Joseph the Carpenter, Yarnell, Arizona (September 2, 1988).

up, to their present site, which is owned and administered by the Tucson Parks and Recreation Department. It is now called the Garden of Gethsemane, or Felix Lucero Park, and is used for weddings, gatherings, and occasional prayer. It is pleasant to see the work of this humble artist accepted and used by the community (Tucson Parks and Recreation Department 1982). His work can also be seen in the Shrine of Saint Joseph the Carpenter near Yarnell, Arizona, just north of the Mogollon Rim, where he was later commissioned to do a dramatic series of larger statues (Weisman 1988). Lucero died in 1951.

The work of another prolific self-trained artist known as Ropy may be found on Sonoran roadsides in and around Ciudad Pesqueira, and as far away as Nácori Grande and Batuc. Ropy was a young vaquero when the Virgin of Guadalupe appeared to him one night and told him he was destined to be a great religious artist. The next day, following her instructions, he found a brush and some paint and created a picture of the Virgin. When we interviewed him in October 2002, he had painted 587 murals on walls and free-standing slabs by the roadside, averaging about 100 murals a year. For a three-by-five-meter mural he would get five hundred pesos. He even filled a commission to decorate a well-known restaurant with murals. Although he has done secular subjects, most of his work is religious. Not surprisingly, his most common subject is the Virgin of Guadalupe, although he also created a large mural of Santa Cecilia, patron of musicians, on the side of a house belonging to a family of musicians.

On Highway 15 between Ímuris and Magdalena is a pair of upright cement slabs, each bearing a picture of the Virgin of Guadalupe. One is signed by Epifanio Molina, the other by his

Ropy and his family, outside their house in la Colonia de Batuc (October 26, 2002).

Santa Cecilia mural by Ropy on a house in Nácori Grande belonging to a family of musicians (October 26, 2002).

son Sergio, both of Ímuris. Epifanio was an enthusiastic self-taught painter of murals and small pictures. For many years he had the restaurant La Diligencia (The Stagecoach) where Highway 15 runs through Ímuris. He displayed his small paintings under a ramada in front of the restaurant. Near the restaurant he built a large shrine featuring a Guadalupe mural. Later on, Sergio began painting and did roadside murals and at least one large picture inside a chapel in Ímuris. These documented artists represent only the tip of an enormous iceberg of roadside muralists, only a few of whom have signed their work.

Just as Ropy did, many roadside artists may need sponsors to pay at least the expenses of their work. Unfortunately, I have no information concerning most of these sponsors. One exception concerns a huge Guadalupe on an upright slab in a roadcut where Highway 2 passes through the mountains east of Ímuris. The word on the road has it that it was commissioned by Rafael Caro Quintero, a formerly prominent drug lord, and that narcotraficantes hold a fiesta there on December 12, serving food to all who stop. Such sponsorship is not surprising, as these major projects are expensive, and the *narcos* are the ones with the most available money, as well as the need for protection on the roads. Several Sonorans have given me this same explanation for the many roadside chapels that dot the highways (Griffith and Manzo Taylor 2006, 252–54).

Another probable example of narco-funded roadside religious art is a huge hillside chapel to San Martín Caballero (Saint Martin of Tours) with an attached mural, on the back road between Trincheras and Santa Ana. According to some people in Trincheras, the owner came suddenly into a large

sum of money, purchased a ranch, and erected the elaborate chapel complex on his new property. Later on, two men called at his house and took him with them, telling his wife he would return later. His body was found nearby. The inference was that all three men were in the drug business, and that an unpaid debt had been collected.

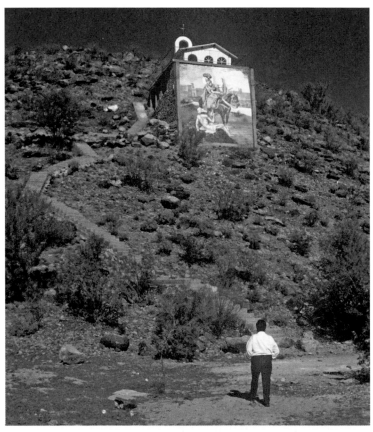

The San Martín chapel on the old road between Trincheras and Santa Ana. Carmen Morales is in the foreground (January 16, 1995).

As we have seen, artists can also be called on to repair or restore older images. With Sonoran Catholics, because the image is so closely tied to the saint it represents, the aim of the restoration is to make the image as beautiful as possible. The image should *lucir* (shine). That the statue might not look precisely as it originally did is of less importance. Many Sonoran churches contain such restored colonial statues, and unless an outsider knows the history of the particular image, it is hard to know exactly what he or she is looking at.

A different restoration aesthetic is also in operation in the region. Statues and paintings in both Sonora and Arizona that have been worked on by professionally trained art restorers are brought back as closely as possible to their original condition in an attempt to preserve the intentions of the artists who created them. All the statues and murals in Mission San Xavier del Bac have been restored in this way. In murals, however, small squares have been left untouched to indicate how the paintings looked before restoration. Yet other images may be preserved as they are to illustrate historical points. For example, there is a statue of San Cayetano (Saint Cajetan) in the museum at Tumacácori National Historic Park. When Tumacácori Mission was burned by Apaches and abandoned in 1849, residents of the village carried the statue, along with the remaining church furnishings, downriver to San Xavier. In 1973 and in 2008, six of these statues, including the partly charred San Cayetano, were returned to the museum at Tumacácori. San Cayetano was deliberately left in his damaged condition to

dramatically illustrate the site's history (Bleser, 2016, 51; Griffith 2000, 26–27).

Now it's time to describe one of the major occasions on which Sonorans come together to visit their religious images— the religious fiesta.

Chapter 4 _____

FIESTAS

Every saint in the Catholic Church has a feast day. For many communities, the day of the patron saint is set aside as a holiday (i.e., holy day) and celebrated with special foods and activities, sacred and secular. A Mass is usually said, fireworks may be set off to banish the presence of evil, and the occasion is further marked in multiple ways. The largest religious fiesta in Sonora is held in Magdalena de Kino on October 4, the Day of Saint Francis of Assisi even though the statue actually represents the Jesuit Saint Francis Xavier, whose day is December 2. This discrepancy may stem from the expulsion of the Jesuits in 1767 and their replacement by the Franciscans. The result is a composite San Francisco who blends characteristics of both Xavier and Assisi (Griffith 1992, 38–39).

People start arriving in Magdalena in late September, and by the day of the feast, the population of the town is easily doubled. Fiesta goers include Native Americans, Mexican Americans, and Anglos from Arizona, as well as Mexicans and Native people from Sonora. Many of these pilgrims have walked for days from such cities as Nogales and Cananea; others have arrived by car, bus, train, and even on horseback. The road is made easy for the walkers from Nogales, who usually

take about two days to travel the sixty miles. Not only does the Red Cross set up relief stations, but free food is offered during the second half of the trek by groups and individuals who have made *mandas*, or religious vows, to do so. Families also set up roadside camps offering food, water, first aid supplies, and shade. Individuals drive along the route, stopping their cars to offer the same. One long-divorced couple from Tucson has for decades gotten together each October to make sandwiches, which they then distribute on the Magdalena pilgrimage route. Even many drivers who don't stop may roll down their car windows and call out "Ya mero!," roughly translated as "You're almost there!" My experience of the Nogales-to-Magdalena

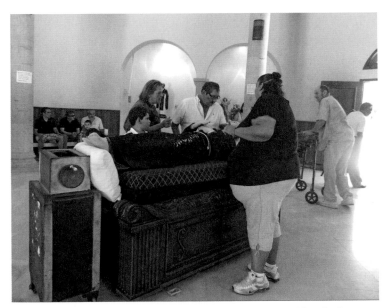

Pilgrims at the statue of San Francisco in the new chapel beside the church, Magdalena de Kino. Author in the background. Photograph by Loma Griffith (June 8, 2014).

foot pilgrimage was that the farther I went and the more tired and sore I became, the more I was buoyed up by unsolicited goodwill coming from all sides. Once pilgrims arrive at their destination, most go directly to the chapel next to the church to pay their respects to San Francisco, whose reclining statue lies in state. Here they pray; caress the statue; kiss its feet, hands, and face; and try to lift its head from the altar table.

Returning to the plaza, they encounter vendors of religious trinkets, medicinal herbs, novelties, household goods, textiles, and local fruits and vegetables. Food and drink stands are ubiquitous, offering fiesta specialties like corn on the cob, corn cocktails, churros, and tacos of carne asada, pork, and *tripas de leche* (marrow guts), as well as flavored drinks such as *horchata*, *tamarindo*, and *jamaica*. Bars serve beer, tequila, and other alcoholic drinks. Joining these vendors are itinerant medicine peddlers, dozens of musicians, and a small carnival complete with rides. Yaqui and Mayo ritual dancers and musicians may perform in front of the church and elsewhere. All this adds to the excitement of the occasion. Many pilgrims come to stay for more than a single day. Motels, hotels, and spare rooms are filled to capacity, and vacant lots are rented out to campers. Many people camp by the river to the west of town.

For those who live in Magdalena, the fiesta is a several-day holiday, a time to put on one's good clothes; to visit, see, and be seen; and to savor all the visual, audible, and comestible delights that come to town only once a year.

Most of those who come to the fiesta for business reasons are from outside the immediate region, and many travel on regular circuits, going from fiesta to fiesta. The late José Moya

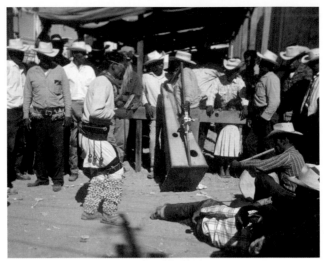

A Mayo pascola dances near the church at the Fiesta de San Francisco. The harp has been decorated with a locally purchased cardboard puppet. The spectators and the sales booths in the background suggest the crowding and excitement of the fiesta (October 3, 1965).

The Magdalena fiesta includes all sorts of attractions. This banner advertises the opportunity to see and hear a young man who killed his parents, turned into a human-headed snake, and was then captured (October 3, 1968).

A fortune-telling device drew a good crowd at the fiesta in Magdalena (October 3, 1968).

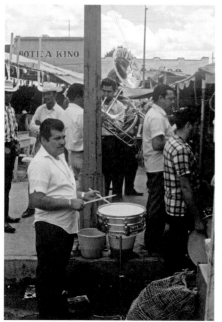

A brass band plays by a food and drinks booth, Magdalena fiesta (October 3, 1968).

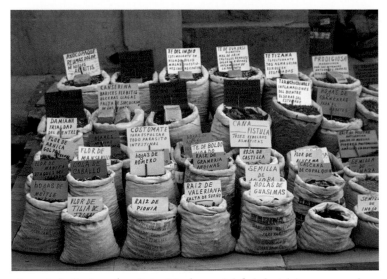

A vendor's display of medicinal herbs, each labeled with its name and suggested use (September 29, 1968).

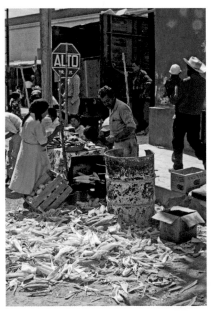

A man selling field corn on the cob between the two plazas at the Magdalena fiesta. Roasted field corn, seasoned with salt, lime juice, and chile powder is a popular fiesta food (October 4, 1968).

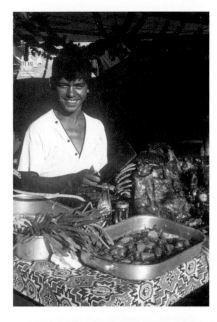

Grilled goat meat tacos for sale, another popular fiesta food (September 30, 1967).

Ingredients for making tacos de tripas de leche (marrow guts tacos) cooking in a booth at the Magdalena fiesta. Such tacos are often accompanied by grilled onions and served with salsa and lime juice (October 1, 1994).

owned a house outside the city of Durango, Durango, where he lived between December and February. For the rest of the year he was on the road as an itinerant fiesta salesman, traveling with his wife from the Guatemala border to as far north as Ciudad Juárez, near El Paso. He would go by bus, picking up his merchandise in Mexico City, where the prices were best, and carrying his goods in suitcases from fiesta to fiesta. Once at a destination, he would rent a space for a booth from the local authorities, purchase the necessary cloth and lumber, and erect a booth. There he would live, with his wife cooking the meals on a portable *bracero*, or grill.

His merchandise consisted of religious items such as medals and holy cards, ribbons, jewelry, and similar trinkets. Because he had been at the work for so many years, he was familiar with what would sell best at each fiesta. At Magdalena, for example, he would stock large supplies of colored ribbons, knowing not only that they were important ritual items for O'odham pilgrims, but also which colors were the most popular. He could speak at least a few words of the many Native languages he would encounter on his journeying. He was a wonderful source of information. I remember sitting in his booth one day at a fiesta in Sinaloa when a couple asked for a picture of San Lázaro (Saint Lazarus). After they left, he remarked that they must have a leper in the family. Leprosy was not uncommon in that area, and Lazarus is the patron saint of lepers.

My late friend Anastacio "Tacho" León lived in Ímuris and made his living as a craftsman and an entrepreneur, as his family had for generations, with only the details changing to fit the times. He made glass and tin frames for holy pictures

and would sell these at the Magdalena fiesta. At the same event he would mend and repaint broken or damaged religious statues brought to his booth for that purpose. Tacho also traveled to fiestas on the nearby Río Sonora and sold corn cocktails. He would run a wheel of fortune game with prizes of sugar that he made himself. A few years before his death, he created and showed me a large open-fronted wooden box containing models of a norteño band. When a coin was deposited, lights would flash, music would play, and the band members would spring into action. Although Tacho León and José Moya are no longer with us, they may stand for all those merchants, large and small, who travel to fiestas to serve the public and augment their incomes.

Tacho León posing by his booth at the Magdalena fiesta (October 4, 2002).

While the Magdalena fiesta is the biggest one in Sonora, each parish, be it in a city or a village, can have its own fiesta on its patron saint's day. Most of these smaller fiestas follow a slightly different pattern from that of Magdalena. There will probably be a Mass and often a procession, featuring the image of the saint carried by townspeople and accompanied by music. If the procession happens after dark, it may be lit by illuminated paper globes or even fireworks. There may also be skyrockets and specially assembled static fireworks displays called *castillos* (castles). Most fiestas, be they large or small, also include such other features as special foods, games of chance, and even *jaripeos* (rodeos) and match races pitting two popular local horses against each other. These last are often occasions for heavy betting, enhancing the day's excitement even more. If a ritual dance group is locally based or has connections in the community, they may well perform during the procession or in front of the church.

Such fiestas draw visitors and businesspeople from the surrounding countryside. They also provide an excellent reason for emigrants to return to their beloved home towns on the most exciting day of the year. Fiestas are cheerful, work-free "times out of time," during which people can satisfy their religious obligations, eat, drink, and visit, while enjoying opportunities for social and other activities that might not otherwise be available to them. They are times for both kinds of negocio. Even small, private fiestas include some of these features. At the roadside chapel to Our Lady of Fátima in El Oasis is a Mass, and all comers are fed; I have been told that *mafiosos* serve menudo at the huge Guadalupe shrine on Highway 2 on December 12. Although I do not know it for sure, I assume

Where there is a fiesta crowd, musicians will show up to play—like this norteño band at a match race at the Fiesta de San Diego, Pitiquito (November 12, 1989).

Team roping at the Fiesta de San Diego, Pitiquito (November 12, 1989).

that the household fiestas for the head of the Black Christ of Aconchi in La Labor involved food for all. In Sonora, it seems that holding a fiesta means feeding people.

※

Some of the details mentioned in this chapter raise questions. Why do the pilgrims walk for days to visit the statue in Magdalena, and when they get there, why do they caress and handle it in these specific ritual ways? Why did people continue to bring their old, broken statues to Tacho León to repair, when similar plaster figures were inexpensive and readily available? Going back to earlier chapters, why do people travel long distances to visit images like the Santo Entierro in Bácerac and the statue of Balbanera in Aduana? Why did Sonorans go to such lengths, often at considerable risk, to save works of art during the persecución? Why are Ropy and others commissioned to paint roadside murals of saints? The following chapters attempt to answer these and other questions.

Chapter 5 _____

SAINTS AND MIRACLES

Saints, according to Catholic doctrine, are individuals who have lived such exemplary Christian lives that upon death they are taken directly into heaven—that is, into the presence of God. The first saint, and the only one that believers can prove to be in heaven, was Dismas, the Good Thief, who was crucified next to Christ on Calvary. Jesus promised him that he would be in paradise by evening, and therefore it must be so. All other saints are simply assumed to be in heaven. This is why miracles are so important in determining a person's sainthood.

According to Catholic belief, only God can perform a miracle, which is defined as a happening outside the course of nature. If one prays to a deceased person to intercede with God on one's behalf and the request is granted, the inferred intervention can serve as evidence of that person's sainthood. In the eyes of both the petitioner and the Church, that deceased person must be in God's company. Although the creation of saints began informally in the early Church, the process gradually became more centralized until 1234, when it came under the control of the Pope. Today, at the beginning of the third millennium, it is very formal indeed. It involves three different stages in which a candidate is first decreed Venerable, then

Blessed, and finally becomes a Saint. The church hierarchy is heavily involved, and internal politics can play an important part. Many, if not most, recently named saints were members of religious orders, and the push for sainthood often comes from within those orders. Even so, the journey toward sainthood starts at the local level, with the deceased individual's cause being brought to the attention of the Church by people who knew him or her in life, and miracles can still be of paramount importance to that cause.

The role of the saints is to intercede with God on behalf of the petitioner—to act as his or her advocates. In popular belief, if one asks for a saint's help and the desired result ensues, there is little reason to doubt that a miracle has occurred. After all, to assume otherwise would be to doubt the power of God. The saints can be asked that a family member's health be improved, or that the petitioner be rescued from a disastrous marriage or some other unpleasant situation. Candles and other offerings placed in front of the relevant image attract the saint's attention and act as a sign of the petitioner's willingness to fulfill the conditions of whatever promise is being made once the request is granted. Because the smoke and flame of a candle rise directly toward heaven, and because candles must be purchased, the candle can serve as both a prayer and a small sacrifice.

If a prayer appears to have been answered, it is customary for the petitioner to do something in gratitude. Sometimes this can involve an act such as wearing the saint's habit over the petitioner's clothing for a specified time, making a pilgrimage, or purchasing a thanks offering of some sort and placing it by the saint's image. These offerings, called ex-votos, from a Latin phrase meaning "from a vow," can take several forms. They

may be plaques, paintings, or even pieces of paper bearing the names of the saint and the petitioner and the date and often the nature of the miracle. In the past, some ex-voto paintings were commissioned from local artists, and might include a depiction of the incident involved. More commonly today, ex-votos take the form of small metal representations indicating the nature of the miracle (Oktavec 1995). These tiny objects, locally called *milagros*, can represent parts of the body, useful animals, and even cars and houses. Although most are mass produced and available from stores selling religious articles, some milagros are specially ordered from jewelers and may even be of precious metals.

Some popular saints' images accumulate quantities of ex-votos. A huge roadside mural of the Virgin of Guadalupe on Highway 15 between Hermosillo and Guaymas, painted as an ex-voto and labeled as such, stands surrounded by hundreds of ex-votos, ranging from tiny nichos to signs and paintings. This site deserves serious documentation; its contents could provide material for an illustrated essay on mid-twentieth-century Sonoran devotional art.

Sometimes one hears of the holy personage acting directly to put things right. Once, when I was standing beside a statue of the Santo Niño de Atocha (Holy Child of Atocha) in Santa Ana Viejo, a small town just west of the junction city of Santa Ana, I was told that a few years previously, a family had been driving through the desert on Highway 15 between Santa Ana and Hermosillo. When they stopped to picnic beside the road, their little boy wandered off and could not be found. After a long and futile search, the child wandered back to the car, well fed, rested, and happy. He told his parents he had been scared

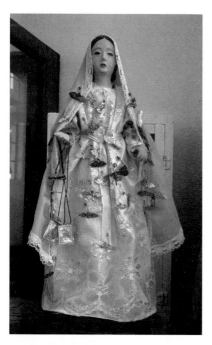

In Huásabas, Santa Lucía is credited with having helped with a lot of eye problems, as one can tell from the large number of eye milagros pinned to her clothing (May 21, 2005).

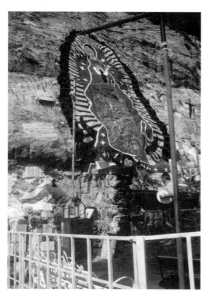

Paco Manzo at the giant Guadalupe shrine on Highway 15. Visible to the left are a few of the thousands of ex-votos at the site, along with the dedicatory sign (September 18, 1999).

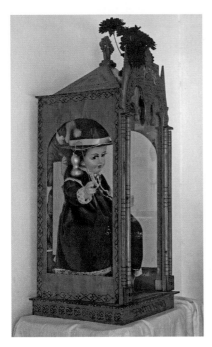

until he found another little boy, who played with him, gave him food from a basket and water from a gourd, and led him back to his family. The tellers had no doubt that the other boy was the Santo Niño, who is usually shown carrying a basket and a water gourd. This is not the only occasion I have been told of when the Santo Niño helped lost travelers in our Sonoran Desert.

Saints can specialize in helping with issues that relate in some way to their lives. Thus, Saint Joseph is the patron of carpenters, and Saint Lucy, who was blinded during her martyrdom, is concerned with eye problems. Many of these patronages are established through Church tradition and can be found in such works as *Butler's Lives of the Saints* (Thurston and

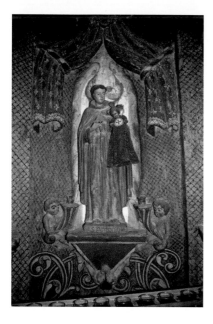

The baroque statue of San Antonio in the west transept of San Xavier Mission. The statue was probably made far to the south and installed in its place around 1792. San Antonio is well known as a finder of lost items (June 17, 1999).

Attwater 1963). Patronages can also be assigned by the folk. San Alejo (Saint Alexis), as well as being the official patron of beggars, can popularly be asked to help remove unwanted neighbors, probably because of the similarity in Spanish pronunciation between Alejo and the verb *alejar*, "to remove or withdraw."

More than one saint can be approached for a specific problem, depending on local custom. The official patron of finding lost objects is San Antonio de Padua (Saint Anthony of Padua) because a supposedly stolen book suddenly reappeared in his possession. ("Tony, Tony, look around, something's lost and can't be found.") In Arizona and New Mexico, however, people can also ask San Cayetano (Saint Cajetan), who, as the informal patron of gamblers, can't resist a bet. One bets him

something inexpensive, like the recitation of a prayer, that he can't find the desired object, and he always rises to the bait (Griffith 2000, 26–27). In parts of Sonora, San Pafnuncio (Saint Paphnutius) is petitioned for the same problem. Paphnutius was one of the Desert Fathers of the third century, but I have been unable to find any published reason that he might be assigned this particular patronage.

Finally, in the Sonoran mission community of Opodepe, when looking for lost objects one addresses a shadowy figure called el Arrastradito (the Little Dragged One), whose body was found in the desert near town in such a condition that it had to be dragged to the cemetery. As nobody knew who he was or whether he was a Catholic or even a Christian, he was buried outside the cemetery fence. When I visited his grave in

Locally, San Pafnuncio can also be turned to for finding lost items. Here he is in his capilla near Ures (April 20, 2002).

June 1991, it was well maintained, with a whitewashed rock pile, a nicho, and a few offerings.

Like el Arrastradito, some individuals whom the Church does not recognize as saints are looked on as such by many traditional Mexican Catholics (Griffith 2003). These "folk saints" include such well-known personages as the *curandero*, or folk healer, el Niño Fidencio and the revolutionary leader and bandit Pancho Villa. Fidencio achieved great fame in the 1920s and 1930s, and his headquarters in Espinazo, Nuevo León, is still an important pilgrimage site for his followers. Villa is usually petitioned to help with the same kind of problems he addressed in his life—he afflicts the comfortable and comforts the afflicted. Both these spirits are channeled by their followers and still give them advice.

Still others, whom I call "victim intercessors," are qualified for popular sainthood only by the fact that they died suddenly or supposedly unjustly (Griffith 2003, 36–40). One such figure in Sonora is el Chapo Charo (Chapo is a nickname meaning "Shorty"). His real name was Rafael Reina, and he was a well-known vaquero and horse breaker in the Altar Valley during the early chaotic years of the Mexican Revolution. At that time and place, many people were stealing cattle and running them across the border to sell in Arizona. Reina got into a violent argument with an Átil businessman named Ochoa, who then formally accused him before the authorities of cattle stealing. He did this "either because of a royal fury or for the pleasure of showing he could do it" (Treviño Guerrero 2010, 142). The Rurales arrested Reina, tied his hands to his horse gear, and started to take him toward Oquitoa. At a given point, they gave him a choice: He could either try to escape or

be shot on the spot. First-class vaquero that he was, he chose the former but did not succeed in outrunning the bullets. At some time after his death, people started discovering that his spirit would help them retrieve lost objects. His fame as an intercessor spread through much of the immediate area (Treviño Guerrero 2010, 142–44).

People have prayed to him for many years, and a chapel was erected to him around 1990 near Oquitoa by a grateful family. It is a small one-room building about a quarter mile off the main Átil-Oquitoa road and has been connected for lighting to the local electric line, which runs along the road. It may well mark the spot where el Chapo fell (Treviño Guerrero 2010, 143–44).

Another Sonoran victim intercessor is Carlos Angulo F., known popularly as Carlitos. He died on January 1, 1940, at about age eleven, when an adobe wall fell on him, and his body lies in Hermosillo's Panteón Yañez (Yañez Cemetery). Another account has him succumbing to meningitis. His grave is unusual; it is marked by a small casket standing on openwork cast-iron legs, the whole thing painted silver. A sign at the foot of the casket tells us that if we pray for Carlitos, the little boy's spirit will help us. Offerings of flowers and toys adorned the grave when I visited it in January 2003 (Griffith 2003, 30–39). A photograph taken on All Souls' Day in 2018 shows, in addition to candles and some flowers, toy cars and trucks; stuffed animals, including a lion, a monkey, and a teddy bear; innumerable balls of all sizes; and even a toddler's large plastic scooter. Some feel that many such offerings are left by children.

Individuals like el Chapo and Carlitos are often referred to as *espiritus*, or "spirits." I learned about these two spirits in

Carlitos's grave, Panteon Yañez, Hermosillo. The space below the little raised coffin was crowded with offerings of flowers and a teddy bear (January 26, 2003).

contrasting ways. When I first heard about el Chapo, I was told that "he got involved in politics in the old days and was given la ley fuga." I then heard about and visited his chapel. Finally, Paco Manzo brought me a book of short articles by Sonoran *cronistas* about the Mexican Revolution in Sonora (Asociación de Cronistas Sonorenses 2010). It included an account of el Chapo, learned from four sources in three different towns. As I mention in the acknowledgments, cronistas are local individuals appointed and given a stipend by the Sonoran government to collect and write down information about their home towns. This information can include historical events and personalities, food ways, legends, and customs. Their work can appear in local newspapers and is sometimes collected and published by the state government in topical volumes, which are invaluable resources concerning the details of Sonoran history and culture.

Only after reading the book Paco gave me did I learn the rich details concerning el Chapo.

By way of contrast, I heard about the existence of Carlitos and the general location of his grave from Paco Manzo. I subsequently visited Carlitos's grave and chatted with the people I met there. The paucity of solid information I acquired in his case results from the brevity of my visit, and especially from the fact that apparently no Sonoran cronista has yet chosen to write about him.

Some narratives highlight the local patron saint's role as the protector of his or her community. The story of San Antonio's intervention at Oquitoa that began this book is one example of this, as is a legend of how San Lorenzo produced an illusionary army with himself at the head to scare off an Apache attack on the Sonora Valley mission town of Huépac in the mid-nineteenth century. We have to date found ten communities in Sonora that have similar stories of saintly intervention in times of crisis, all set in the nineteenth or twentieth century. The usual pattern is that the saint provides the illusion of a powerful defending or relieving force. Such traditional narratives of divine intervention and aid occur in many religious traditions, as far back in time as ancient Greece and as recently as the twentieth-century Holy Land. The specific Catholic antecedents stretch back to the Spanish Battle of Clavijo in 844, when Santiago (Saint James the Greater) was seen off to one side, slaying vast quantities of Moors. These Sonoran legends of saints saving their villages are discussed more fully in appendix C of this book.

Chapter 6 _____

RELIGIOUS ART AND ITS MEANING IN THE COMMUNITY

Now it's time to peel our cultural onion a bit further. I have discussed the history and appearance of the art and how it is used in various cultural settings and events. Now we can look at how it serves as a channel of communication between the human and the divine worlds. Finally, I examine the rationale behind these actions and beliefs, involving the relationship between God, the art, and the believer.

Representational religious art has a place in the official Catholic world because it not only reminds the viewer of sacred qualities and narratives but can serve as a focus for devotional prayer and reflection (Wroth 1982, 3–5). Many traditional Mexican Catholics go a step further, believing that a sacred image can in some way take on some of the attributes of the person it represents. The Church would call such an object a "sacramental." Although the two words are related, sacramentals are distinct from the Seven Sacraments. These were instituted by God, and include baptism, confirmation, marriage, and holy communion. They bestow God's grace on participants. Sacramentals, by contrast, are created by the Church (Broderick 1976, 333–34). After being blessed for the purpose, sacramental objects can take on some of the aspects

of the individuals or concepts they represent. One example of a sacramental is the prayer candle, which, in addition to being a symbol of prayer, can actually assist in wafting the request heavenward. In the case of an image, the blessing may be done by a priest or may occur when the image is prayed over, in which case the image may then enhance communications between heaven and earth. Steele (1974, 46) refers to this kind of sacramentalism as "folk Platonism." Another term used for it is "neoplatonism." The spirit represented by the form is seen to be present in that form. The scholar William Christian put it this way in his essay "Images as Beings in Early Modern Spain" (Christian 2009, 75): "The image (like a relic) assumed in immanent form some of the attributes and power of the saint it represented, and in the eyes of the devotees there was an overlap between divine being and image."

In the most common aspect of this particular form of neoplatonism, the petitioner addresses the saints through their images. For example, San Ramón Nonato (Saint Raymond the Unborn, so called because he was delivered by caesarean section) is the patron of childbirth. Women who wish his help not only pray to him, but place his picture under their pillows while they are going through the ordeal, thus keeping their petition dramatically before the saint and keeping the saint involved in the process.

Equally, those in heaven can use their images to communicate with those on earth, as the la Virgen de los Remedios let it be known that she wanted her statue to stay in Nácori Grande, even though it was intended for Mátape. Such communications can sometimes have great urgency. Here is a story I heard from the sacristana of the church of San Ignacio de

Cabórica concerning the Black Christ statue in the church at Ímuris, a few miles away. Once a very pious man lived in the village. Every day he would pray before the life-sized crucifix and finish his prayers by kissing its feet. A jealous man, aware of this custom and wishing to murder the first man for his possessions, smeared poison on the statue's feet. When the pious man finished praying, a mysterious force prevented him from kissing the feet of Christ. Looking up, he saw first the feet, then the rest of the body turn black as a warning. The pious man did not die, and the statue remained black as testimony of a miracle.

Speaking historically, that statue was black in 1856, when the Gadsden Purchase caused the Mexican garrison of the Tucson presidio to move to Ímuris, taking their statue of the Black Christ of Esquipulas (a Guatemalan devotion) with them. In 1995, the local priest had the statue "restored" to its European flesh tones (Demara García 2008, 39; Officer, Scheutz-Miller, and Fontana 1996, 80; Griffith 1995, 88–91). Who knows how long the legend of how the statue turned black will survive after the "restoration."

In an even more dramatic account of a saint working through his image, the following story was told me by Santa Fe, New Mexico, santero (saint maker) Charlie Carrillo: When Charlie's uncle was a little boy, the family lived by the banks of the Río Grande. One day the child was playing beside the river when a sudden flood swept him away. His mother ran to the house, grabbed a statue of San Antonio from the family altar, and threw it into the river, shouting something like "Go get him!" The unharmed child was discovered playing on a sandbar downstream. Beside him stood the saint's statue. For

the family, this is a story of action and effect, suggesting another reason why a woman in labor might put a picture of San Ramón Nonato under her pillow: where the image is, there also is the saint himself.

I must emphasize that this is not idolatry, which most dictionaries define as the worship of idols or other human-created objects. These images are not worshiped, although they are believed to possess certain powers bestowed on them by God. It is generally accepted that the miracle is performed not by the image but by the saint, working through his or her image. The concept is graphically illustrated in a painted Italian ex-voto, or thanks offering, dating probably from the early twentieth century. In it a man is shown trapped under an upturned cart. He gestures for help to a nearby roadside shrine containing an image of the Virgin. The Virgin is seen hovering over him, hearing his prayer, and a beam of light flows from her statue in the shrine down to the victim. Thus we are shown that she listened because of, and responded through, her image (Briscese and Sciorra 2012, 101).

I am bringing Italian devotional art into this discussion because Mexico was colonized from Spain, and Spain, though at the western edge of the Mediterranean world, is in many historical and cultural aspects a solid part of that world. Much of what I describe for Sonora has strong parallels and antecedents in Spain and Italy, as shown in the previous chapter's discussion of Santiago.

At this point one might well ask, "But isn't Mexican popular Catholicism famous for its strong indigenous flavor? What about all those 'idols behind altars' that one hears about?" While this may indeed be the case in central and southern Mexico, it

seems much less so in the northwest. There are a few exceptions, such as those found in the Yaqui and Mayo Easter ceremonies, and a few tantalizing artistic traces remain in the art from the early period of colonization. In the mission church in Pitiquito, the didactic murals I described earlier include elaborate baroque frames that appear to mark the stations of the cross. Hidden beneath some of these, on the earliest layer of whitewash, investigators have found square painted frames outlined in red ochre and filled with white kaolin. Some of these frames include what appear to be cloud and other symbols. These may well have been painted by local O'odham, with a strictly O'odham meaning (Fontana 1996, 72). These and other minor details, however, are really scattered Native notes in a predominantly European composition.

A probable O'odham sacred painting at Station of the Cross XII in the Pitiquito mission church. These ochre and kaolin paintings are found on the earliest levels of plaster on the church walls (April 10, 1999).

The following vignettes were chosen to illustrate the notion that these images are connected to their sacred subjects in special ways. The connections between saints and their images can be complex and multidirectional. When I talked with Tacho León about his work as a restorer of sacred statues, he told me that many of the people who brought their art to him believed that damage to the statue reflected some suffering on the part of the saint. This suffering might have been inflicted as a result of having worked a miracle on behalf of the petitioner. The inference here seems to be that, just as God desires a reciprocal act of giving from the human petitioner, so he does from those saints who intercede on behalf of humans.

I was told the following story by members of a family with Sonoran roots, living in the Arizona mining community of Winkelman-Hayden. The father of the family is known in his community for painting saints' images, and also for repairing damaged statues. They once owned a house in the flood plain of the Gila River. During a particularly heavy flood one year, the family of five fled the house. When they returned, they found that the water level inside the flooded house had reached higher than five feet, and that the interior water pressure had forced a large refrigerator through the back wall of the building. In an inner room, on what had been the family altar, stood the statues of five saints, each one without its head. A family member explained to me that these saints had sacrificed themselves for the good of the family, one for each family member.

Many images are cared for in special ways. Statues, especially of the Virgin, are often beautifully dressed, as they are

all over the Mexican world. Clothing for statues is typically prepared by women, perhaps members of a church organization formed for that purpose. The dresses may be changed regularly, often to coincide with the feast day appropriate to that image. For example, at San Xavier del Bac a group of women take responsibility for creating new clothing for the statue of la Virgen Dolorosa, and they frequently prefer to clothe her in pastel shades rather than the more common black. The clothes on some statutes are preserved; the pilgrimage church in Ocotlán in Tlaxcala has a beautiful special chamber, the *camarín*, which is devoted to the Virgin's many costumes. It is interesting that this luxurious dressing of images was condemned by the Council of Trent (1545–1563)—a condemnation that was eagerly echoed by the higher clergy in Spanish America. It is equally interesting that, more than three hundred years later, Mexican Catholics still dress their beloved images in the richest and most wonderful garments available (de Ceballos 2009, 25, 28). Remember in this context that for many Sonoran Catholics, the distinction between an image and its saintly subject is blurred, and that a gift left by a statue of a saint is a gift given to that saint to be used as he or she wishes. In just this way, money left at the Fátima chapel in El Oasis is spent to buy food so that the Virgin can feed the people who come to her fiesta.

That said, different images of the same saint may have individual identities and personalities. Thus, vows of pilgrimage made to the reclining San Francisco statue in Magdalena should not be repaid by walking to San Xavier del Bac, where there is a similar statue. Nuri has two statues of the Virgin of the Rosary. The original small statue was hidden in a cave

during the persecución and partially destroyed by rats. A replacement, described as larger and prettier, was purchased and installed in the church. Nevertheless, the people of Nuri consider the smaller statue "their" Virgin. When *nureños* get drunk at a fiesta, we are told that they call out *vivas* to "la virgen de Nuri—la chiquita, no la grandota" (the Virgin of Nuri—the little one, not the great big one; Pineda Pablos 2003, 49)

Many devotional images are considered to be important members of their communities (Vanderwood 1998, 37–38), and on family altars, they may be regarded as members of the family. Such beloved images are deemed worth preserving, even at the expense of considerable effort or even risk. When the 1887 Bavispe earthquake leveled the adobe mission church of Santa Rosa de Lima (Saint Rose of Lima, patron of earthquakes, d. 1586) in Fronteras, a woman living near the church handed her son a shovel and told him to go to the collapsed building and dig up Santa Rosa. This he succeeded in doing, and when we visited Fronteras in June 2004, we found the statue in the main room of the family's house, in a tall glassed-in case, where she could be visited by all comers. Standing about three feet tall, Saint Rose wears a crown of flowers and tenderly holds the Christ Child, a reference to a mystical vision. Her pale gown is covered with estofado, or tooled floral designs on gold leaf. This embellishment, along with the delicacy of the flesh tones and the saint's graceful posture, indicates a colonial origin for the statue. I can see no reason that it should not date to the late seventeenth century, when the first church in the vicinity was dedicated to Santa Rosa (Roca 1967, 178–79).

For me the very presence of this statue is a kind of miracle. Every time I visited a church or drove through the countryside,

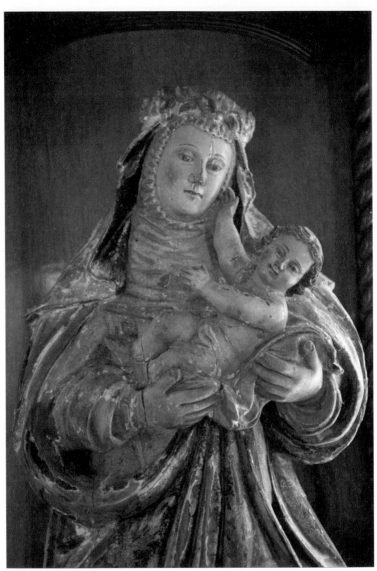

The Santa Rosa statue that was saved from the ruined church in Fronteras after the 1887 Bavispe earthquake. She now stays in a private house, available to any visitors (June 26, 2004).

unexpected art revealed itself, turning long, hot, dusty days into strings of joyful encounters. And if it wasn't the art, it was the stories. And if the stories didn't show up, the grace and hospitality of the rural Sonorans were enough to make what we called "work" rewarding.

※

Let's end this discussion with one more narrative. A family in Magdalena owns a small sheet of copper on which is painted the image of San Isidro Labrador (Saint Isadore the Husband-man). This saint was an agricultural worker whose employer accused him of wasting valuable time by praying on the job. Indeed, the employer found him so engaged, but also found that an angel was plowing the field for him.

The small painting in Magdalena may date from the nine-teenth century. It is said to have been in its present family for several generations, during which time it was often car-ried through the fields in procession during years of extreme drought to show the saint the gravity of the situation, and even sometimes buried in the field with threats that it would remain there until San Isidro produced rain. On one of these occa-sions, unexpectedly heavy rains washed the picture down the arroyo, whence it was duly recovered and replaced on its altar.

More recently, the picture caught fire from candles around the altar, and all the paint was burned off. The family hired a young man from a nearby Magdalena barrio to repaint it. The present painting is not skillfully executed, but it shows the same scene as in the previous one. According to the family, the object is essentially the same as it was, complete with whatever

power it had possessed, even though it looks different from the original in many ways. It becomes obvious that, at least with this painting, "art" is less important than iconographic accuracy and spiritual continuity.

Such attitudes toward sacred art are not universal throughout Christianity. Even the image-rich Mediterranean world had occasional strong iconoclastic movements. And northern Protestantism, with its insistence on strict adherence to biblical injunctions, has little use for devotional art. I have been given a tract that specifically mentions the reclining statue of San Francisco in Mission San Xavier del Bac. When a little boy asks his father why he lifted the statue's head, the author answered, "because the statue can't lift its own head!"

He follows this with a short sermon in which he emphasizes the evils of idolatry, says that Jesus is the one true way to God, and gives the family a Gospel of John.

A totally secular and more violent iconoclasm was the major feature of the most searing period in recent Sonoran history—la persecución, or la cristiada, of the 1930s. The final chapter of this book is devoted to this time of conflict.

Chapter 7 _____

MEMORIES OF LA PERSECUCIÓN

In many ways la persecución was a defining moment for twentieth-century Sonoran Catholicism, and ironically enough, this state-led effort of "defanatization" seems to have resulted in even stronger connections between Sonorans and their images. Virtually every practicing Catholic we interviewed gave us narratives referring to la persecución. Most of these accounts concerned the destruction or rescue of individual pieces of religious art, but occasionally we were given a broader view of this time when churches were closed, images burned, and Catholicism literally forced underground. One of our first interviews was with a woman in Ures, who said that she had lived on a ranch that was the site of clandestine Masses said by a priest who was in hiding in the mountains. The Blessed Sacrament was kept at her family's house between visits. She told us of how wonderful it was to have Jesus always present in that time of trial. Not once did she mention the real dangers that this involved. As we consider the following narratives, it is important to realize that many of those who worked against government policies did so at considerable risk to themselves.

Bishop Juan Navarrete moved from Hermosillo to the sierra, where he established a clandestine seminary from which he would cross over into Arizona at any serious threat of a government raid. His energetic resistance has led to his cause for sainthood being taken up in Rome. We also heard of Padre Francisco Navarrete, the bishop's younger brother, who hid among the people in the railway town of Empalme, near Guaymas. One day he appeared in workingman's clothing at the site of a fatal accident, administered the last rites to the dying man, and disappeared into the crowd of onlookers. There is a chapel dedicated to this priest in the Guaymas cemetery. Like his brother the bishop, he is considered a saint by some Sonorans.

✳

Despite the efforts of the faithful, many beloved images did not escape the quemasantos. Perhaps the most famous case of such destruction involves the reclining statue of the composite San Francisco in Magdalena. I will treat this episode in some detail, as it incorporates many of the elements mentioned in previous chapters.

According to tradition, the original statue was brought to Magdalena by Father Eusebio Francisco Kino, SJ (1645–1711), the first and most famous missionary to work in the Pimería Alta. He had intended it for the church that he planned to build at San Xavier del Bac, just south of present-day Tucson. When the statue arrived in Magdalena, however, it could not be moved, which was taken as a sign that the saint desired his image to remain there. Since at least the early nineteenth century, this statue had been the focus of pilgrimage and

devotion. Currier and Ives and the great Mexican popular artist José Guadalupe Posada made widely distributed prints of it.

In 1935 the image was removed from the church by quemasantos, taken to the capital city of Hermosillo, and burned in the furnaces of the Cervecería Sonora (Sonora Brewery). This act is seen to have had serious consequences for many of those involved: a school teacher who danced on the ashes of a statue she had burned is said to have gone mad, and it was said that the furnace assistant fell ill with *espanto* (literally "fright"—a traditional sickness akin to shock) and died two weeks later (Bustamante Tapia 2006, 47–48). Others who helped in the act of desecration of the church are believed to have met with equally unpleasant and suitable ends.

Many of the faithful took the statue's ashes away to their home altars. I have also been told that the saint did not allow his statue to be destroyed, but that the local priest gave it to faithful Papago Indians (now called Tohono O'odham), who carried it to one of their villages near the border, where a similar image remains today. An O'odham friend told me that, according to his mother, it rained during that journey, both as a blessing and to confuse the "Spanish soldiers." Several years later, another statue—the one which is now in Magdalena— was created and installed. This replacement statue seems to possess all the powers of the original. (For a fuller account of aftermath of the statue's destruction, see Griffith 1992, 50–54.)

This statue currently lies on an altar slab in a separate, recently built chapel beside the parish church. When people visit it, they usually try to raise its head off the slab where it rests. If this attempt is successful, it is taken as a sign of the saint's favor; if not, there is a serious need for fence mending in the form of

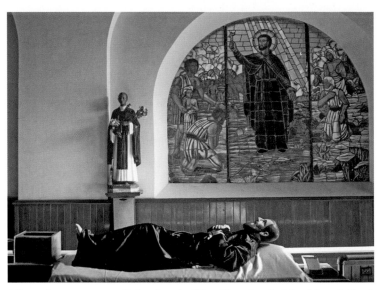

The replacement statue (lying down) of San Francisco in Magdalena before it was moved to its present chapel. Visitors can pass on both sides of the image. The stained glass window shows San Francisco Javier preaching in India, while the standing statue represents San Martín de Porres (April 8, 2002).

prayer, penance, or both. This penance can often take the form of a promise to perform some such act as wearing a habit or making a pilgrimage to the saint's image. If the saint perceives that this promise is not being kept, however, he can visit revenge on the unfaithful supplicant, often in the form of fire. This has led to the often-repeated statement that San Francisco is a miraculous saint, but one who demands a payment.

✳

This destruction of precious images took place all over Sonora. In a well-remembered incident on the Río Mayo, Juan Pacheco,

local *jefe de la policía rural* (chief of the rural police), entered the Mayo Indian village of Júpari, removed all the images from the church, and burned them on the nearby river bank. This was remembered by local Mayos as "when they burned the Little Children"—the saints who are close to the heart of the Mayo sociocosmological structure (Bantjes 1998, 7). As the story goes, the statue of San Juan Bautista escaped by jumping into the river, and Pacheco tried to shoot him. This is a clear instance of what in Mexico is called *la ley de fuga* (the law of flight), by which a prisoner is shot "while trying to escape."

Some images, like the Black Christ of Aconchi, were partially rescued and continue to serve at least some of the

San Juan as the Mayos see him. He wears a straw hat and red, the color of martyrdom. According to Mayo belief, after Herod beheaded him, God gave him the head and face of an innocent child upon his arrival in heaven. Located in San Pedro, Río Mayo, just downstream from Navojoa (January 12, 2007).

Doña Etelnidora Gil lovingly shows all that remains of la Virgen de la Candelaria (August 23, 2002).

community. Here are a few more: A small, badly charred statue of la Virgen de la Candelaria (the Virgin of Candlemas) had been rescued from the burning chapel of the Hacienda de los Tepehuanes, near Álamos. It remains in the possession of doña Etelnidora Gil, in Barrio Zapópan of that city. The statue's legs and hands were burned off, its arms reduced to charred stumps, and its upper body smoke blackened. Traces of estofado are visible on its singed and blackened skirt. What was left of the body is now held upright by being wedged into an empty tin can. Nevertheless, doña Etelnidora had carefully dressed what was left of the statue, and she handled and smiled at the statue with

apparent love—a love that seemed to have little to do with any monetary or aesthetic value the image might possess.

A statue of la Purísima Concepción (the Immaculate Conception) stands in a wall niche in the patio of the former *casa cural*, or priest's house, near the center of Álamos. The Virgin is missing her feet, as well as the globe and serpent that she usually stands on. The family that currently lives in the house rescued the statue from the quemasantos after it had been cut into pieces and was about to be burned. The father of the present family was unable to save the entire statue but made what repairs he could before dressing it. The statue

The statue of the Immaculate Conception in the former casa cural in Álamos. The camera angle of this photo allows us to see the "happy" aspect of her face (March 23, 2002).

The face of the Guadalupe painting in Bacanora that was partially destroyed by quemasantos and rescued and restored by a young man. It now hangs in its gold frame inside the church (May 28, 2005).

is about three feet tall, with jointed arms and a sweet facial expression. Concerning this expression, we were told that "La virgen a veces se pone alegre, y a veces triste" (The Virgin sometimes becomes happy, and sometimes sad). Indeed her expression seems to change depending on the angle from which one sees her face.

In Bacanora, after the quemasantos left, a young man found pieces of the face of the Virgin of Guadalupe, all that was left of a heavily slashed large painting. He patched the image together and hung it in the church, where it remains to this day. The Virgin receives many petitions, most of which

are granted. When I visited Bacanora and saw the painting, I was told that the villagers consider the rescue miraculous and will not allow the painting to be moved, even to another part of the church.

✳

Villagers who had enough warning often hid their saints. Some statues were hidden behind hastily constructed false walls in churches, only to be discovered years later. A statue of Saint Peter was found behind a wall in the parish church of Álamos around the year 2000. A painting of the Virgin of Guadalupe was walled up in the church at Bácerac until the danger had passed. The patronal statue of Our Lady of the Rosary in Rayón was placed in the church's Chapel of the Adoration of the Host, which was then walled up (Ramírez Dominguez 2008, 135–36).

Others were hidden in caves, as was the statue of San Francisco Borja (Saint Francis Borgia), patron of the Lower Pima village of Maycoba. It was the only image in that village to escape the police, who on December 9, 1931, reported that all the images in the church had been burned. Yet, San Francisco had been hidden in a cave called del Cuervo (of the crow). One year on his locally celebrated feast day, October 4, he was taken from his hiding place and was carried out in procession on the orders of the village presidente—an event known only to the villagers. Had the procession been discovered by the authorities, the penalties might have been severe in the extreme (Beaumont Pfeifer and Rodríguez Bertha Alicia 2001, x).

The statue of San Francisco Borja in the Lower Pima community of Maycoba (March 2008).

Still other statues were buried, as was a life-sized crucifix called el Señor de Buen Retiro, or el Señor del Molinote, which has been in the Río Sonora Valley since at least 1781 (Morfi 1967). It now hangs above the altar in a small church in El Molinote, downriver from Baviácora, where Father Morfi had seen it. I have been told that the statue was discovered when a vaquero saw its head sticking out of the ground. The assumption is that it was buried, lost, and then rediscovered. Its face appears to have been somewhat battered, possibly during the statue's interment or rescue. It is accompanied in its chapel by more than a hundred milagros, most representing parts of the body.

The small statue of Balbanera that Guadalupe Valdez smuggled out of the Aduana church. This might be the statue that, according to legend, was discovered in a nopal cactus. The Virgin has been given a wide variety of milagros, including automobiles (April 3, 2001).

In Ímuris a beautiful large statue of the Virgin was buried in the patio of a prominent citizen, while the woman in charge of an organization that looked after the church's contents hid the other images, along with vestments and ornaments, in her own house. When the Virgin's statue was dug up in 1937, it was surprisingly in perfect condition (Corella Romero 2008, 67–68). We have been unable to locate and identify this statue.

At least one image was literally snatched from under the hand of destruction. In Aduana, a few miles from Álamos, the quemasantos were entering the church when twelve-year-old Guadalupe Valdéz picked up the tiny statue of the Virgin of

Balbanera, wrapped it in her rebozo, and fled for home, muttering "Ciéganlos, vírgencita, ciéganlos!" (Blind them, dear little Virgin, blind them!). The colonial-era statue was later returned to the church, given a new dress, and still stands by the altar of the church.

One image survived through serendipity. In December 1932, a woman in Caborca removed the statue of the Santo Niño from the mission church to fit it with new clothes for the Christmas season, as was the custom. While the statue was in her house, the quemasantos came to Caborca and destroyed the images in the church. The woman kept the image of the Holy Child in her house, holding an annual fiesta for him in

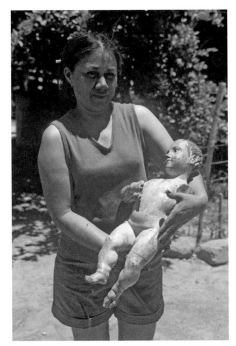

The Santo Niño de Caborca in the arms of his current hostess. This realistic statue has a wonderfully expressive face (June 6, 2004).

December. At her death, her husband kept the statue but discontinued the fiesta. When he died of tuberculosis, most of his possessions were burned, but the statue was thrown into the Río Concepción, which runs near the old church. Later on, two vaqueros saw what they thought was a doll hanging in the branches of a tree on the river bank. It was the Santo Niño, and one of the men took it to his home. There it remains, well cared for, to this day (Santini de Vanegas 2002; Griffith and Manzo Taylor 2007, 18–20).

Finally, a statue of the Virgin of the Rosary presides over the dining table in the house of Manuel Edgardo Contreras Castillo, in Puerto Peñasco. The statue was rescued during la persecución by Manuel's father, Francisco Contreras, who fled his home in Rayón on the Río Sonora, taking the Virgin with him. According to the family account, he cared for the image, and, in turn, the Virgin protected him while they hid together. Later the statue traveled to Opodepe, then to the Rancho Lista Blanca near Caborca, and finally to Peñasco. The statue has been in the family for many years and passes to the youngest brother.

The statue is about three feet tall and stands on a gilt baroque stand painted with flowers. Its torso is painted blue, suggesting that it was intended to be dressed. Aside from the stand, the torso, and the wooden body, all that remains of the original statue are the carved wooden head and arms of the Virgin and the head and right hand of the Christ Child she holds. Although her face has been repainted, the hands seem to have been left in their original finish. Details of the work suggest that it might date from the very late colonial period. The Christ Child has been either reconstructed or covered with rolls of stiffened

The Virgin of the Rosary as she appears in her preferred place on the dining table in her home. Undated photograph by Myrora Moreno Corona.

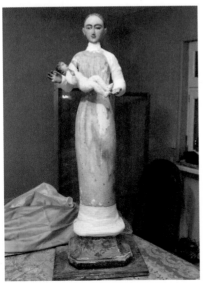

All that remains of the Virgin of the Rosary. Her head, hands and body appear to be original, as do the head and one hand of the Child and the polychromed wooden stand. The rest is careful reconstruction. Her essence, however, is unchanged. Undated photograph by Myrora Moreno Corona.

yellow cloth, while white stiffened cloth attaches the head to the torso and the body to the base. The image is crowned and dressed in pink. The Virgin always wears earrings, which are occasionally replaced by members of the family and other devotees. Indeed she received a pair with the Virgin of Guadalupe on them at the time of our visit.

When we asked if there were any plans to place the image in a separate chapel to make it more available to the public, we were told, "She loves fiestas, she likes music, and what she likes to do is live in the house, surrounded by the family; that's why she hasn't been in a chapel." A family in New Mexico heard of the Virgin and asked her that their son might "return healthy and happy from the war in Vietnam." When this was granted, the family asked the Contreras family what the Virgin wanted in exchange. The response referred to a tradition that when a petition to the Virgin was granted, one must take her a new dress. We were again told that she likes fiestas and music—especially accordion music.

With this final vignette it becomes completely obvious that we are not dealing with an object of art, but with a powerful member of the family who is not afraid to make her wishes and opinions known. And this is as good a place as any to close our discussion of the role of religious art in Sonora.

AFTERWORD

In this book I have examined the religious art of Sonora, both as objects with a history and as part of a functioning belief system. We have seen how the art was created, how it arrived in Sonora, and how it came to be preserved, cared for, and integrated into Sonorans' lives. With the last topic, we switched categories and began to move deeper into our subject. It became apparent that these statues and paintings are more than "art objects"; through being dedicated to a sacred purpose, they have acquired the ability to serve as vehicles of communication between this world and heaven. Not only can the faithful use the images to make their wishes known to the saints and to God, but the saints can respond through their images, as when the Virgen de los Remedios refused to leave Nácori Grande, or when a reclining image of San Francisco shows his disapproval of a pilgrim by refusing to allow its head to be lifted. We have seen that some images can be beloved members of their community or family. This is especially apparent in the stories from the persecución in which people took great risks to preserve their saints. It must be noted that in all the narratives that we have found from both parties in that violent period, nobody mentioned aesthetics or referred to the category that Western culture calls "art."

Different groups of people have approached the objects I have been writing about from radically different directions. For the Vatican, they are aids to worship and contemplation. For traditional Sonoran Catholics, they can be vital communication links between this world and heaven, beloved members of the community for whom it is appropriate to risk one's life. This latter was especially true during the persecución. For the quemasantos, they were "idols," "fetishes," and dangerous impediments to the noble project of bringing the people into the light of secular socialism. For the art historian, these objects—especially those dating from the colonial period—are insights into the past, to be studied, explained, preserved, and perhaps enjoyed aesthetically. The Sonoran approach that involves the repainting of beloved but battered old images to make them *lucir*, or "shine," in a way befitting their importance would cause a professional art restorer to cringe with horror. This same practice, however, can discourage any potential art thieves by destroying the objects' value on the collector's market. It must be emphasized that nowhere in my readings and field interviews have I found any traditional Sonorans mention "art" as a separate topic. Finally, folklorists may use the objects, histories, and legends as data in order to try to move toward an understanding of the culture that "owns" them, while acknowledging whatever effect the images and their narratives may have for the investigator. I try to stand on the outside, noting all approaches and judging none, while cheerfully admitting that much of what I have recorded has an aesthetic and emotional impact on me.

Our journey has necessarily been long and scattered, sometimes reminding me of my dogs when I take them on a

walk in the desert. They do not stick to a straight line but dash off to investigate interesting sights and smells. Despite these detours, they always arrive at their final destination, which is home. Similarly, after all the meanderings we have been through, I hope that we have arrived at a fuller understanding of Sonoran religious art and how it fits into the region's history and culture.

I want to end on a personal note. My journeys have been infused with a sense of wonder: wonder that the art came to Sonora and that so much has been preserved. Wonder and joy that I find so much of it exciting. Wonder at the faith shown by the Sonoran communities that lovingly (and stubbornly) preserved and protected their precious artistic and spiritual heritage through good times and bad. And finally, grateful wonder at the universally generous and enthusiastic reception the Sonorenses have offered us when we entered their churches, photographed (and often disrobed) their saints, asked many questions, and even took notes on the answers. At many houses where we stopped to ask questions, we were invited inside to share coffee and such local delicacies as beans and homemade cheese and tortillas. Sonorans are outstanding for their gracious hospitality, even in a country where those qualities are highly valued and omnipresent.

La Virgen de Esperanza in Jécori. Although the man in whose house this statue stays was out of town when we inquired about images rescued from the quemasantos, some of his neighbors went in and brought her to a window. I took this picture through the screen. It makes a fitting close to what is in some sense a book about faith and generosity (July 3, 1999).

APPENDIX A

Verbal Religious Art

Over the course of this project, we heard many narratives, often given in answer to our questions. Except for the story of the Black Christ of Ímuris, all were given informally as parts of casual conversations. In that case the sacristana took us into her house, sat down in the hall with us, and proceeded to give us the legend in a rather formal manner. Another more formal kind of verbal religious art we encountered was memorized traditional prayers. These have long been a part of Sonoran verbal lore and have been collected by such scholars as Acosta (1951, 125–31).

Here are the ones we elicited (my translations):

Santa Barbara doncella	Saint Barbara, virgin
Que del cielo fuiste estrella	You who were a star in heaven
Líbranos del rayo millagrado	Free us from the forked lightning
Y todas las centellas.	And all the thunderbolts.

| San Jorge Bendito, | Blessed Saint George, |
| Amarra tu animalito. | Tie up your critter. |

[to be said on seeing an unwelcome animal such as a scorpion or snake]

Ángel de la Guardia,	Guardian Angel,
Dulce compañía,	Sweet companion,
No me desampares	Do not forsake me
Ni de noche ni de día.	Neither by night nor by day.

[This is usually taught to young children as a bedtime prayer.]

| San Isidro Labrador, | Saint Isidore, husbandman |
| Quita el agua y pone el sol. | Stop the rain and let the sun shine. |

APPENDIX B

Sacred Personages Mentioned in the Text,
with Their Feast Days

THE HOLY TRINITY

God the Father, God the Son, and God the Holy Spirit. Not to
be confused with the Holy Family, which consists of Jesus,
Mary, and Joseph.

CHRIST

El Señor de los Afligidos (Lord of the Afflicted Ones). The
seated Christ, resting on the path to Calvary.

Nuestro Señor de Esquipulas. A sixteenth-century crucifix, said
to have been created for the residents of the Guatemalan
pilgrimage center of Esquipulas by Spanish sculptor Quirio
Cataño. Originally of darkish wood, it has probably been
further blackened by exposure to smoke. Associated with
healing earth, the image and its devotion spread North
through New Spain, eventually getting as far as Chimayó,
New Mexico. An image of Esquipulas was in the Tucson
presidio in the 1850s and was carried to Ímuris when the
garrison moved there after the Gadsden Purchase.

El Niño Dios. The Christ Child.

Santo Niño de Atocha. A statue in Plateros, Zacatecas, showing the seated Christ Child, dressed as a pilgrim to Compostela, and holding a staff, water gourd, and basket of bread. The devotion came from Atocha in Spain, where a legend had the Child carrying bread and water to Christian prisoners of the Moors. When a statue of Our Lady of Atocha, complete with removable Child, was given to Plateros, the Child at some point was separated from his mother and given his own devotion (Cruz 1995, 19–29). He helps prisoners, children, and miners.

Santo Niño de Praga (Holy Child of Prague). A sixteenth-century Spanish statue of the Infant Jesus given to a church in Prague in 1628 by a Spanish noblewoman. He is seated and crowned, and he blesses with his right hand while holding an orb in his left.

The Risen Christ. The living Christ after the Crucifixion. Usually shown clad in white, with the wounds of his ordeal visible.

Santo Entierro (Holy Sepulcher, or Holy Burial). A statue of the entombed Christ with jointed shoulders, which allows it to be taken from the cross, placed in a bier, and carried in Good Friday processions.

THE BLESSED VIRGIN MARY

Apocalypse (the woman described in Revelations 12:1–2). She is clothed in the sun, with the moon under her feet and a crown of twelve stars, and is about to deliver a child. She has been variously described as the Virgin Mary or the Milagrosa. Details in several traditional depictions of the Virgin, for example, Remedios and Guadalupe, borrow from this description.

Asunción. The Virgin did not die but was "assumed" into Heaven, carried by angels. She is shown clad in white, often with angels at her feet. August 15.

Balbanera (also *Valvanera*). A devotion transplanted from Spain, where an ancient frontal statue of the seated Virgin and Child was discovered in an oak tree. The Sonoran version of the legend has changed the oak into a prickly pear cactus. Venerated in Aduana, Sonora, November 21 (Fontana 1983, 81–92).

Candelaria (the Virgin of Candlemas). Originally honored the day on which the Virgin was purified after childbirth (now called the Feast of the Presentation of Our Lord). On this day candles are traditionally blessed by the Church. The Virgin is shown standing, holding her Child. Each holds a candle. February 2.

Dolorosa (the Sorrowing Virgin at the foot of the cross). Shown with hands clasped and eyes turned upwards toward her Son. A dagger of sorrow may pierce her breast. In Sonoran missions, she is often a bulto de vestir.

Fátima. The Virgin as she appeared to three children in Portugal on May 13, 1917. She asked that all the world pray the rosary for peace. She is shown clad in white with gold trim. May 13.

Guadalupe. The Virgin as she appeared in 1531 to the Indian Juan Diego (now San Juan Diego) on the hill of Tepayac outside México-Tenochtitlán. His *tilma*, imprinted with her image, now hangs over the altar in her basilica, now the most important shrine in all Mexico. She is the patron of Mexico. Also known as la Virgen morena (the dark-skinned Virgin), she particularly cares for Indians and per-

sons of mixed race. On one roadside shrine near the edge of traditional Yaqui country, she is labeled "My beloved Yaqui." December 12.

Luz (Light). A Jesuit devotion, shared by Franciscans, which began in Italy and spread to New Spain in the eighteenth century. The depiction shows the Virgin pulling a soul from the mouth of hell with her right hand while holding the Christ Child in her left hand. The Child is pulling two flaming hearts, symbolizing souls in purgatory, from a basket. A large painting of her hangs above the main altar in the church at San Ignacio (Taylor 2016, 277–80).

Loreto. The Holy House of the Virgin Mary is said to have been carried away by angels when its site was overrun by Muslims. Its final destination was Loreto, Italy. In this important shrine is an ancient statue of the Virgin and Child, said to have been carved by Saint Luke with divine assistance. The Virgin holds her Son so that his head is visible above her shoulder. The statue is dressed in a long garment, with only the Virgin's head and the Child visible. All statues of Our Lady of Loreto are derived from this model, with the child physically attached to his mother. Saint Ignatius Loyola, founder of the Jesuit order, had a profound religious experience at the Holy House in the 1520s and later passed the devotion to Our Lady of Loreto on to his Jesuit followers. Sonoran images of and dedications to her likely date from before 1767, when the Jesuits were expelled from New Spain (Taylor 2016, 268).

Refugio de Pecadores (Refuge). Shows the crowned Virgin from the waist up, on a cloud, holding the crowned Christ

Child. This image was beloved of the Zacatecan Franciscans, who worked in late eighteenth-century Sonora. Paintings of her occur in several Sonoran missions (Taylor 2016, 280–84).

Remedios. A small statue of the Virgin and Child said to have been brought to México-Tenochtitlan by Hernán Cortéz. While the insurgents in the War of Independence marched under the banner of Guadalupe, Remedios became the patroness of the Royalist army, and her aid has often been invoked in conservative causes. She is shown crowned, standing on a crescent moon, and holding the crowned Christ Child. Her image is usually dressed in a triangular garment. December 8 (Cruz 1993, 301–2).

Rosario (Our Lady of the Rosary). She urged Saint Dominic to preach the use of the rosary for praying when he was combating the Albigensian heresy in 1214. She is shown holding the Infant Jesus, both of whom dangle rosaries from their right hands.

Soledad (la Virgen de Soledad al Pie de la Cruz). A statue of the Sorrowing Virgin that arrived mysteriously in Antequera (now Oaxaca City) in a pack belonging to a strange mule. She is now the patron of Oaxaca, and the church of la Soledad was built on the site of the discovery.

Zapópan. A small statue of the Immaculate Conception made of cornstalk paste by Indians in the sixteenth century and brought to Jalisco around 1541 by the Franciscan Fray Antonio de Segovia. It resides in Zapópan, now a suburb of Guadalajara, and is greatly venerated. December 18 (Cruz 1995, 286–88).

Angel de la Guardia (the Guardian Angel). The unseen angelic representative and companion of everyone on earth.

San Miguel Arcángel (Archangel Michael). He battled with the Devil in the Book of Revelations (12:719). He is the leader of the heavenly host and protector of the faithful. He is shown winged, wearing Roman armor, and holding a sword, often with the devil under one foot. September 29.

SAINTS

I have used Delaney (1980), Kelly and Rogers (1993), and Sandoval (1997) as my major sources for this list.

Agustín (Saint Augustine of Hippo, 354–430). A great theologian, doctor of the Church, whose writings had a permanent influence on Christian thinking. August 28.

Alejo (Saint Alexis, fifth century). A pious man who, after conversion and years as a hermit, returned to live as an unrecognized beggar in his family's house in Rome. Patron of beggars, but, perhaps because his name resembles the Spanish word for "far away," he is invoked in Mexico to rid one of unwelcome neighbors. July 17.

Antonio (Saint Anthony of Padua, 1195–1231). A great Franciscan preacher. He is usually depicted tonsured and holding the Infant Jesus on his arm because a visitor saw him doing so. Invoked for the return of lost articles. June 13.

Barbara (Saint Barbara, fourth century). There is no historical record of this legendary virgin martyr, who is said to have been imprisoned by her father, who insisted that she marry. After she had three windows representing the Holy Trinity cut into her wall, her enraged father took her up

on a mountain and killed her. He was instantly destroyed by fire from heaven. Patron of miners, artillerymen, and all who use explosives, and invoked against lightning. December 4.

Cecilia (Saint Cecilia, third century). A Roman martyr who heard only herself singing to God while music played during her wedding. Usually shown playing an organ. Patron of musicians. November 22.

Cayetano (Saint Cajetan, 1480–1547). A great reformer, who started Church-sponsored pawn shops to help the needy. In the American Southwest he is considered to be the patron of gamblers, possibly because they are often in need of ready cash. August 7.

Diego (Saint Didacus, 1400–1463). Born into a poor Spanish family, he joined a recluse and cooked for him until becoming a Franciscan. He worked as a missionary in the Canary Islands, then spent the rest of his life in Spain. He was noted for his healing powers and miracles. The patron of cooks. November 13.

Dismas (Saint Dismas, the Good Thief). Crucified next to Christ (Luke 23:39–43). Jesus promised him that they would dine together in paradise. March 23.

Francisco de Asís (Saint Francis of Assisi, c. 1181–1226). The founder of the Order of Friars Minor (the Franciscans), he underwent a conversion experience, after which he perceived a unity in all living things and embraced a life of poverty and service. He is shown tonsured, wearing a brown or gray habit, and often holding a skull, with the stigmata of Christ on his hands and feet. The patron of Catholic action, animals, and ecologists. October 4.

Francisco Borja (Saint Francis Borgia, 1510–1572). A member of the Spanish branch of the famous Borgia family, he left the world of statesmanship to become a Jesuit in 1551. A famous preacher, he served as father general of the Jesuits, and revised the society's rules. Invoked against earthquakes. October 10.

Francisco Javier (Saint Francis Xavier, 1506–1552). A friend and personal follower of Saint Ignatius of Loyola, founder of the Society of Jesus, or the Jesuit order. He became a missionary, working in India, the Spice Islands, and Japan. He died on an island off the coast of China while preparing to go on a mission to that empire. His incorrupt body lies in Goa, India. He is usually shown preaching while holding a cross aloft, but in Sonora he is portrayed lying on his death bed. Patron of missionaries and unofficial patron of the Pimería Alta. December 3.

Isidro Labrador (Saint Isidore the Husbandman). An agricultural worker whose employer accused him of praying rather than working. He was found in prayer while an angel plowed his field with a team of snow-white oxen. Shown in blue smock and high boots, praying while the angel plows. The patron of farmers. He is invoked to bring rain. May 15.

Jorge (Saint George). The mostly legendary saint who slew the dragon. Patron of, among other things, professional exterminators. April 23.

José (Saint Joseph). The husband of Mary and a carpenter. Shown bearded and often holding a staff from which a lily grows, in reference to a legend that when he gathered with other eligible young men to decide who would be betrothed to the Virgin Mary, his staff burst into flower. Patron of fathers, happy death, and carpenters. March 19.

Juan Bautista (Saint John the Baptist). He preached repentance for sins, baptized Christ, and was beheaded by Royal command. He is usually portrayed as bearded, barefoot, and clad in a camel's skin. His day is the traditional beginning of the summer rains in Sonora. June 24.

Juan Evangelista (Saint John the Evangelist). The "disciple whom Jesus loved" who stood at the foot of the cross and cared for the Virgin Mary till her death. He is traditionally considered to be the author of the Fourth Gospel and the Book of Revelations. He is shown as young, bearded, often clad in a green cloak. December 17.

Judas Tadeo (Saint Judas Thaddeus). One of the twelve disciples. He is depicted wearing a green cloak and holding a staff. A large medal hangs around his neck. He is the patron of hopeless cases and desperate situations. His image is common in roadside Sonora. October 28.

Lucía (Saint Lucy, fourth century). A Sicilian martyr who is traditionally invoked for eye trouble, partly because her martyrdom involved blinding, and partly because her name means "light" in Latin. Often shown holding a plate containing two eyes. December 12.

Lázaro (Saint Lazarus). Brother of Martha and Mary and the man Jesus raised from the dead. Believed to have been a leper, he is invoked against that disease. December 17.

Lorenzo (Saint Lawrence, d. 258). An early Christian martyr who was roasted to death on a gridiron. He instructed his executioners to turn him over, as he was already cooked on one side. His symbol is, of course, a small grill. August 10.

María Magdalena (Saint Mary Magdalen). One of Jesus's most important followers, and the first person to discover the

empty tomb. Believed by some to have been the woman who washed Jesus's feet and dried them with her hair. Often depicted with her hair down and her feet bare. She is the patron of fallen women. July 22.

Martín Caballero (Saint Martin the Horseman, or Saint Martin of Tours, c. 316–397). A Roman soldier who cut his cloak in half and gave the half to a beggar. When Christ appeared to him in the evening wearing the half cloak, he left the army. He later became Bishop of Tours. He is depicted on horseback and in uniform, in the act of cutting his cloak. He is patron of beggars, harvests, and, in a sense, plenty, as kitchens and stores in the Mexican world where his picture is hung are believed to never run out of food or business. The phrase "San Martín Caballero, el que trae el dinero" (Saint Martin the horseman, he who brings the money) reflects this belief. November 11.

Martín de Porres (Saint Martin of Porres, 1579–1639). The Peruvian-born son of a Spanish knight and a Panamanian freedwoman, he became a Dominican lay brother in 1594. A deeply humble man and a friend of Saint Rose of Lima, he founded an orphanage and devoted himself to serving the very poor. He is remembered as a miracle worker and a bilocator. He is patron of people of mixed race. November 3.

Pafnuncio (Saint Paphnutius, fourth century). An Egyptian desert father who became a relentless opponent of heresy, he is for reasons I cannot discover invoked in Sonora to find lost articles. He is shown bald and bearded and wearing a brown habit. In this portrayal he kneels in prayer before a makeshift stone altar. The skull suggests solitary meditation. September 15.

Pedro (Saint Peter). The disciple to whom Christ entrusted his church and the first Pope. He is shown as a bearded old man, and his symbol is the keys to heaven. June 29.

Ramón Nonato (Saint Raymond the Unborn, c. 1204–1240). So called because he was delivered from his dead mother by caesarean section, he joined the Mercedarian Order and went to Algeria to ransom Christian slaves. While there he had his lips pierced and padlocked to prevent him from trying to convert his Muslim captors. He is invoked for assistance in childbirth and against false accusations. August 31.

Rosa de Lima (Saint Rose of Lima, d. 1586). Born in Lima, Peru, of Spanish parents, she was the first New World saint to be canonized (in 1671). Because her prayers were believed to have saved Lima from an earthquake, she is invoked against those natural disasters. August 23.

Santiago de Compostela (Saint James the Greater). One of the twelve disciples, who is believed to have been buried in Spain. After his tomb was "discovered" at Compostela in Northwest Spain, he became patron of Christian Spain and was believed to have been seen slaying vast numbers of Moors at the Battle of Clavijo in 844. He later performed a similar function during the Spanish conquest of Mexico and is the patron of the Spanish Army and of the militant expansion of Spanish Catholicism. His name became the Spanish battle cry and is used poetically today to describe the start of a horse race. July 25.

NONSAINTS

Carlitos (Carlos Angulo F.). Killed at about the age of ten, probably when an adobe wall fell on him. Considered "a

spirit," he receives petitions and ex-votos at his gravesite in Panteón Yañez in Hermosillo (Griffith 2003, 39).

El Arrastradito (the Little Dragged One). A body of an unknown man found in the desert near Opodepe, dragged into town, and buried outside holy ground. His grave is still maintained, and he is believed locally to help find lost objects (Griffith 2003, 38).

El Chapo Charo. An early twentieth-century man from Átil who is said to have gotten into politics and been murdered by his opponents. There is a chapel to him near Oquitoa (Griffith 2003, 38).

El Niño Fidencio (José Fidencio Constantín Síntora). A famous faith healer who worked in Espinazo, Nuevo León, between 1927 and his death in 1938. He attracted pilgrims from all over Mexico, as his shrine in Espinazo still does. He is frequently channeled by his devotees (Griffith 2003, 139–43).

Jesús Malverde. A legendary bandit near Culiacán, Sinaloa, who is believed to have operated around 1900. Said to have robbed from the rich to give to the poor, he has become the informal saint of the narcotraficantes. His shrine in Culiacán attracts thousands of devotees (Griffith 2003, 64–89).

Pancho Villa (Doroteo Arango). A revolutionary general and sometime bandit in Chihuahua until his death in 1923. Considered either a hero or a villain by many, he is also a folk saint often invoked to do what he was famous for in life: afflict the comfortable and comfort the afflicted (Griffith 2003, 90–107).

Santa Muerte (Holy Death, or Saint Death). She has devotees all over Mexico, who go to her because she responds positively and requires nothing but devotion (Chesnut 2013).

APPENDIX C

*Sonoran Legends of Saints Saving
Their Villages from Attack*

Over the course of our project, we have encountered ten So-
noran legends in which saints intervene to save their namesake
churches and communities from outside attack. One way in
which folklorists can organize narratives for comparative pur-
poses is by reducing them to their individual motifs. A motif
is the absolutely smallest narrative element in a given text. To
give an example, the motif of the Oquitoa legend that opened
this book could be "Saint rescues village by creating the illu-
sion of a defending or relieving force." With this technique,
we can look at our cluster of legends and see if we can find
any patterns they share. These are the three motifs we have
encountered so far.

MOTIF 1: SAINT TAKES DIRECT ACTION TO FOIL
ATTACKERS
(In Caborca, 1857; Nácori Chico, 1883; and Nuri, 1922)
In Caborca, in April 1857, a group of American soldiers of
fortune led by Henry Alexander Crabb were besieging the

mission church of Nuestra Señora de la Purísima Concepción (Our Lady of the Immaculate Conception), where the Caborcans had taken refuge. (The church is almost always the sturdiest and largest building in any Sonoran village and has traditionally been used as a refuge in times of attack.) At one point in the battle, Crabb's men tried to blow in one of the church doors with a barrel of gunpowder. According to a legend known to both Mexican and O'odham families, a Lady in Blue appeared and put out the fuse. Few doubt that this was the Virgin, who is usually shown dressed in blue, protecting her community (Forbes 1952; Redondo 1993, 258–59).

In Nácori Chico, in the sierra far to the south and east of Caborca, in January 1886, the troops of the U.S. Army expedition against the Apaches under Captain Emmet Crawford were returning home and passed through the village. Some of the Apache scouts who accompanied the regular soldiers visited the church, which is dedicated to Saint Rose of Lima. They commented that the statue of Santa Rosa over the altar appeared to be the same long-haired white woman who had kept them from attacking the village on a previous occasion, by flying through the air and throwing something like ashes in their eyes. Some of the women of the village were in the church during the Apache visit and heard the older scouts discussing this. The story was also confirmed later by Geronimo on a visit to Bácerac before his surrender and deportation from the border country (Fuentes Yañez 1991).

There was indeed an aborted Apache attack on Nácori Chico, and Geronimo did take part in it. In July 1883, an estimated 150 warriors lay in wait for the local farmers to go to their fields. They were spotted by an early riser, and a skirmish ensued, with

the Mexican soldiers bearing the worst of it. Then "four brave men" from the village charged the Apaches. The latter, thinking these were reinforcements, retired (Sweeney 2010, 328).

In 1922, the sierra village of Nuri was threatened by a roving group of *colorados*. This is the popular name given to the followers of revolutionary general Pascual Orozco (1882–1915), one of the early leaders of the Revolution in the north, because of the red neckerchiefs they wore. Although Orozco was long dead and his movement had presumably broken up by 1922, oral tradition in Sonora attributes several attacks to remnants of this group. All we know is that some army, locally believed to be colorados, was actively harassing Sonoran towns during that year. The attackers bypassed the village when they heard an alarm bell ringing from the church. According to village tradition, the bell ringer was the Virgin of the Rosary, patron of Nuri (Pineda Pablos 2003, 49).

I have heard a second legend current in Oquitoa that explains the failure of the Indian attack mentioned in the introduction. All of a sudden, at the height of the assault on the church, a "crazy old man" started jumping onto the backs of the attackers' horses and grabbing their arms and bows, causing them to miss their shots. The old man was identified as San Antonio by the narrator of this variant.

MOTIF 2: SAINT CREATES ILLUSION OF DEFENDING OR RESCUING FORCE

(In Oquitoa, c. 1869; Bacoachi, c. 1870; Cuquiárachic, late nineteenth century; Pueblo de Álamos, late nineteenth century; Huépac, late nineteenth century; Ures, 1922; and Huachinera, c. 1922)

Around 1869, a mixed group of Papagos, Seris, and Yaquis were attacking the village of Oquitoa, in the Altar Valley, as described in the introduction. Long after the attackers had suddenly melted away, the villagers learned that a relief column had been seen, led by a man who was unmistakably described as their patron San Antonio.

The village of Bacoachi, on the upper Río Sonora, also has its legend of a saintly defender. Around 1870, a large group of hostile Apaches led by Geronimo was nearing the town wall, which was then in ruins, when a "brave Captain" on horseback was seen to come out of the church, with a shining sword in his hand. He was followed by a large and well-equipped army. The Indians fled. The villagers decided that the army, which only the attackers had seen, was led by their patron, San Miguel (Salazar Gudiño 2005, 67–68).

At some time in the late nineteenth century, Apaches were attacking the then-walled village of San Ignacio de Cuquiárachic, a few kilometers from the presidio (military outpost) of Fronteras. Once again, the situation was desperate, but the attackers fled at the sight of a column led by the village patron, Saint Ignatius Loyola, who, my informants reminded me, had once been a soldier. Incidentally, the statue of San Ignacio in this church has him carrying a sword—in my experience, a unique attribute of that saint. Cuquiárachic indeed had a long history of Apache attacks, one of which, in December 1847, was so successful that the village was abandoned in February of the following year, not to be resettled until sometime around 1860 (Sweeney 1991, 64, 222).

In the late nineteenth century, Pueblo de Álamos (a former mission community to the south and west of Ures and not

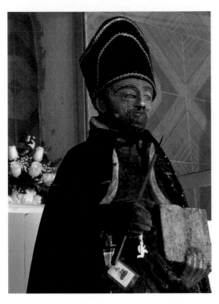

The statue of San Ignacio in his church in Cuquiárachic. He carries a sword, denoting that he had once been a soldier (June 26, 2004).

to be confused with the famous colonial silver-mining city of Álamos farther to the south) was being attacked by Yaquis. They, too, dispersed when they saw a relief column that was not seen by the defenders. The officer leading the column was identified as San Ignacio.

In the same general period, Huépac on the Río Sonora was also under attack by a large force of Yaquis. They were frightened off by the appearance of a horseman, clad in shining white and brandishing a flaming sword. He was accompanied by an overpowering number of troops wearing white uniforms and cloaks that shone brilliantly in the sunlight. When the villagers learned this explanation from a lad who had escaped from captivity among the Yaquis, they realized what had happened: they had been saved by their patron San Lorenzo (Montoya López 2005, 67–68).

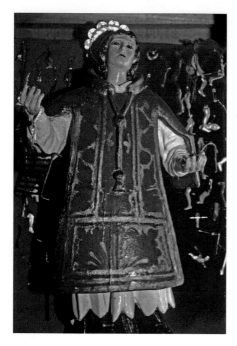

*San Lorenzo at Huépac.
The milagros surrounding
the statue show that this
saint is still actively
receiving and answering
petitions (May 29, 1999).*

In 1922, a group of colorados (possibly the same army that
is said to have threatened Nuri) was on the verge of attacking
the former Sonoran capital of San Miguel de Ures. Yet, their of-
ficers, who were posted on a hill to the west of the town, saw that
the roof of the church and the plaza in front of the church were
full of soldiers, being encouraged by an officer on a white horse,
waving a sword. The army made a detour around the town and
continued into the sierra. The villagers themselves knew that no
such troops existed but put their rescue down to an illusion cre-
ated by their patron, Saint Michael. He is almost always shown
with the sword that he used to defeat Lucifer in a cosmic battle
between good and evil.

Huachinera, on the Río Bavispe, was also threatened by colorados at about the same time. The community was saved by the appearance of the village patron, San Ignacio Loyola, mounted on a dapple gray horse and carrying a "bright sword." He was in command of an organized army, a larger force than that of the attackers (Castillo Medina 2005, 114–16).

MOTIF 3: ATTACKERS FLEE WHEN THEY SEE AND MISINTERPRET A RELIGIOUS PROCESSION
(In Opodepe, late nineteenth century)

Although this last motif doesn't involve the action of any saint, it seems to fit with the other narratives. The threat is the

San Miguel Arcángel standing above the door of his church in Ures (May 9, 1992).

same as in the others, while the unexpected solution, involved as it is with a traditional religious observance, could easily be interpreted as a miracle.

When I visited the mission community of Opodepe on the Río San Miguel, I had the opportunity to interview an elderly member of the community. He told me the following story: One year, the Apaches were poised to attack the village at dawn on Good Friday morning. One group was hidden in low hills on one side of the village, the other in some hills on the opposite side. All of a sudden, drums sounded, trumpets blared, the church doors were flung open, and a procession of men carrying swords and spears issued forth and started to march around the plaza. Fearing that their plans were known to the villagers, the Apaches melted away into the brush. The "soldiers" were actually participants in a Holy Week drama then common to many missions in Sonora and still presented annually in many Yaqui and Mayo villages. Armed with wooden swords and spears, they represented the fariseos—Pharisees—who later in the day would crucify Christ, and then be defeated in combat the next day, on Holy Saturday. In fact, there is some possibility that the mysterious and now much altered pebble murals on the church façade represent just such a series of ceremonies.

❋

Hearing this story from Opodepe reminded my friend Tom Steele of a similar incident involving an attack during a religious procession in Mapimí, Durango. In this case hostile Indians attacked a Holy Thursday procession carrying a cru-

cifix, which was struck on the leg by an arrow and started bleeding. The attackers fled. The wounded crucifix became known as El Señor de Mapimí, and was moved in about 1715 to the less isolated community of Cuencamé, Durango, where it is still venerated (Steele, pers. comm., n.d.; Valles Septien 1994, 74). There is another statue of el Señor de Mapimí in the cathedral in Chihuahua City. Unlike the statue in Durango, this one is a Black Christ (Valles Septien 1994, 67). El Señor de Mapimí is mentioned in the famous Sonoran corrido "La Carcel de Cananea" (Griffith 2002, band 3).

✳

Five of the Sonoran legends (Caborca, Oquitoa, Opodepe, Pueblo de Álamos, and Cuquiárachic) were collected from informants in the villages. One (Ures) comes from a Sonoran newspaper article, and four (Nácori Chico, Huépac, Bacoachi, and Huachinera) from publications by official cronistas or local historians.

✳

SOME PARALLEL LEGENDS

Most of these stories are obviously related to the Spanish legends concerning Santiago de Compostela, or Saint James the Greater. He was believed to have first helped the Christians against the Moors at the Battle of Clavijo in 844, actively taking part and killing sixty thousand or more of his enemies (Simmons 1991, 8– 10). After that violent beginning, Santiago, whose name became

the battle cry of Catholic Spain, fought alongside the Spaniards in most if not all the major battles of the *conquista*. When Catholic Spain embarked on the conquest of the Americas, Santiago was invoked for assistance. He is said to have appeared, riding his white horse out of a cloud, accompanied by Saint Peter (who was Cortéz's personal patron) in a closely fought battle in Tabasco in 1518. Later on, during la Noche Triste, the retreat from Tenochtitlán, Santiago fought along with the Spaniards, aided this time by the Virgin Mary, dressed in white, who threw dust in the eyes of the Indians (Simmons 1991, 17, 18). Years later and hundreds of miles to the north, Santiago, assisted by the Virgin, fought on the side of the Spaniards in the battle at the Pueblo of Acoma in 1599 (Simmons 1991, 25). One very late appearance was in 1862 in Tabasco, when he joined the Mexican army to help defeat a force of French invaders (Simmons 1991, 19). Today, the word "Santiago" is sometimes used to indicate the start of Sonoran horse races.

A closer parallel to the Sonoran legends that does not involve violence on the part of the intervening saint comes from the Southern Colorado community of San Acacio. In 1853, a large force of Muache Utes was about to stage an attack on the settlement. Seeing no hope of worldly resistance, settlers prayed to their saintly patron. The Indians turned away, apparently under the impression that they had seen a superior force of defenders (Lamadrid 2002). Lamadrid mentions other New Mexico legends paralleling the Sonoran ones: San José scared off the horses of the enemy by hitting them with his staff, paralleling the interventions at Oquitoa and Caborca in a sense, while matachín dancers at San Antonio and Tularosa

were mistaken for soldiers by bands of Apaches, who "re-treat[ed] in fear," paralleling the Opodepe legend.

The belief that deceased heroes can return in the midst of battle to help the living is much older than the Santiago legends. Greeks fighting the Persians at the Battle of Marathon in 490 BC were said to have been joined in their struggle by none other than Achilles (Cahill 2003).

On the near end of the time scale, Pancho Villa and his army were planning a night attack on the Mormon community of Colonia Dublán, Chihuahua, on the night of March 13, 1916. The townsfolk, hearing of the plans, spent the night in prayer. According to the Mormon account, Villa, and Villa alone, saw the town filled with troops and campfires. The attack was called off, and the village was saved (Perry, n.d.).

Mormons have also told the story that in the late twentieth-century struggles between Arabs and Jews, the vastly out-numbered Jewish forces were saved by the appearance of an army led by a white-bearded old man, dressed in white. Any Mormon could easily identify this figure as one of the three Nephites, sent by God to wander the world setting things right for the faithful (Wilson 2006, 243).

This ends our listing of legends. It is interesting to note that from the Battle of Marathon to the Israeli-Palestinian conflict of the twentieth century, there are really only three basic plots. One thing this might tell us is that these are very old motifs, which have been used and reused for millennia. We are also reminded that in most cases, we are dealing with traditions that have their roots in the Mediterranean region. Not earth-shaking discoveries, perhaps, but nice to know.

What do the living legends from Sonora have in common? In the first place, the saints intervened to help defend "their" villages, which were under attack. In each instance, the attackers were invariably non-Catholic outsiders, unbelievers. All the communities are the sites of former missions (Roca 1967) and therefore might be considered especially under saintly protection. And it is protection we are dealing with here, rather than conquest. The saints act, but in only three cases are their actions direct; in seven others, they depend on the creation of illusions. In the tenth case, an illusion is created by the sacred activities of the villagers themselves.

The legends certainly convey a sense of divine protection. But protection of what? In Lamadrid's discussion of the Santiago legends, he cites Bakhtin's concept of the "foundational legend." In this approach, the saint can be said to justify the Spanish military efforts against the Moors and the Aztecs by participating in them. The Christians were *meant* to win, and to occupy the territory in question. Similar arguments can be used to explain San Acacio's intervention on behalf of the newly established Christian settlement under his patronage (Lamadrid 2002).

But nineteenth- and twentieth-century Sonora, though a heavily contested land, was in no real sense a recently conquered or occupied one; the situation seems to be a bit different than it was when Santiago and the Virgin acted on behalf of the Spaniards. In the Sonoran legends, the saints seem to be protecting their territory against all hostile non-Catholic comers. And what they are protecting is not Mexico, nor the Christian religion, or even the state of Sonora, but rather the individual villages.

This concept of the home village as *la patria chica*, or "the little fatherland," is widespread throughout Mexico. Many Mexicans traditionally self-identify as being from their village or town, then perhaps a subregion, then their state, and only then as Mexicans. There are many different kinds of evidence in the popular literature for this attitude in traditional Sonoran culture. One is the "hometown corrido"—not a narrative ballad like the corridos that most folklorists have written about, but rather a paean of praise for one's hometown or village. Such a song is the "Corrido de Oquitoa" in Griffith (2002, band 6).

One can find a sort of "reverse of the medal" approach to the concept of the patria chica in the rich body of Sonoran oral poetry that insults someone else's hometown. Take for example the "Oda a Nogales" (Ode to Nogales) said to have been composed by Ignacio Romero in the 1940s (Manzo Taylor, pers. comm., May 6 and June 5, 2000).

Cuarenta cerros pelones	Forty bald hills
Una calle pavimentada	One paved street
Putas, gringos y cabrones	Whores, gringos and SOBs
Y un viento de la chingada.	And a f—ing great wind.

(Manzo Taylor 2002)

Back to the legends of saintly rescues. Our community, the stories tell us, is so important that the very saints of heaven rally to its defense. And this sense of living in a place so special that it merits divine protection is perhaps one of the major factors in the survival of this particular web of narrative.

REFERENCES

Acosta, Vincente Sánchez. 1951. "Some Surviving Elements of Spanish Folklore in Arizona." Master's thesis, University of Arizona, Tucson.

Anonymous. n.d. "Relato de la Imagen de Santo Entierro." Photocopied 8 × 10 page purchased in Bácerac, Sonora.

Asociación de Cronistas Sonorenses. 2010. *La revolución Mexicana: Hechos y personajes de Sonora*. Hermosillo: Instituto Sonorense de Cultura.

Bantjes, Adrian A. 1998. *As If Jesus Walked On Earth: Cardenismo, Sonora, and the Mexican Revolution*. Wilmington, DE: Scholarly Resources.

Barragán Martínez, José Luís, ed. 2008. *Crónicas, leyendas, fiestas y tradiciones: Lo nuestro de los municipios de Sonora*. Hermosillo, Sonora: Editorial Garabatos.

Beaumont Pfeifer, David Joseph, and Duarte Rodríguez Bertha Alicia. 2001. *Los Pimas: Catálogos de piezas arqueológicas pertenecientes a la zona indígena Pima*. Hermosillo: Estado de Sonora.

Bleser, Nicholas J. 2016. *Tumacácori: From Ranchería to National Park*. Tucson: Southwestern Mission Research Center.

Briscese, Rosangela, and Joseph Sciorra, eds. 2012. *Graces Received: Painted and Metal Ex-votos from Italy—The Collection of Leonard Norman Primiano*. New York: John D. Calandria Italian American Institute, Queens College, City University of New York.

Broderick, Robert C. 1976. *The Catholic Encyclopedia*. Huntington, IN: Our Sunday Visitor.

Bustamante Tapia, Francisco. 2006. *Leyendas de Magdalena*. Magdalena de Kino: Editorial Sonora Mágica.

Cahill, Thomas. 2003. *Sailing the Wine-Dark Sea: Why the Greeks Matter.* New York: Doubleday.

Calles Gonzáles, Ángela María. 2003. *Pedro Calles: El Hombre y el Artista.* Hermosillo: Museo Regional de la Universidad de Sonora.

Castillo Medina, Jesús Manuel. 2005. "Las Fiestas de San Ignacio de Loyola." In *Crónicas, leyendas, fiestas y tradiciones: Lo nuestro de los municipios de Sonora*, edited by José Luís Barragán Martínez, 114–16. Hermosillo, Sonora: Editorial Garabatos.

Chesnut, R. Andrew. 2013. *Devoted to Death: Santa Muerte, the Skeleton Saint.* Oxford: Oxford University Press.

Chick, Jack T. 1988. *The Death Cookie.* Chino, CA: Chick Publications.

Christian, William A., Jr. 2009. "Images as Beings in Early Modern Spain." In *Sacred Spain: Art and Belief in the Spanish World*, edited by Ronda Kasl, 175–99. Indianapolis, IN: Indianapolis Museum of Art.

Corella Romero, Pamela, ed. 2008. *Ímuris, Voces de mi Pueblo.* Hermosillo, Sonora: Editorial Garabatos.

Crumrine, N. Ross. 1997. *The Mayo Indians of Sonora: A People Who Refuse to Die.* Tucson: University of Arizona Press.

Cruz, Joan Carroll. 1993. *Miraculous Images of Our Lady.* Rockford, IL: Tan Books.

Cruz, Joan Carroll. 1995. *Miraculous Images of Our Lord.* Rockford, IL: Tan Books.

Dallas, S. n.d. *A Visit to the San Xavier Mission.* Apache Junction, AZ: Tract Evangelists Crusade.

de Ceballos, Alfonso Rodríguez G. 2009. "Image and Counter-Reformation in Spain and Spanish America." In *Sacred Spain: Art and Belief in the Spanish World*, edited by Ronda Kasl, 15–35. Indianapolis, IN: Indianapolis Museum of Art.

Delaney, John J. 1980. *Dictionary of Saints.* Garden City, NY: Doubleday.

Demara García, Mtra. Czilena. 2008. "San Esquipulas: El Cristo Negro de Ímuris." In *Crónicas, leyendas, fiestas y tradiciones: Lo nuestro de los municipios de Sonora*, edited by José Luís Barragán Martínez, 37–39. Hermosillo, Sonora: Editorial Garabatos.

Eckhart, George B., and James S. Griffith. 1975. *Temples in the Wilderness: The Spanish Churches of Northern Sonora, Their Architecture, Their Past*

and *Present Appearance, and How to Reach Them*. Historical Monograph no. 3. Tucson: Arizona Historical Society.

Encinas Blanco, Ángel. 2008. *"Cuando enmudecieron las campanas"* . . . *y luego repicaron alegres con Navarrete*. Hermosillo, Sonora: Instituto Municipal de Cultura y Arte.

Encinas Blanco, Juan. 2016. *Iglesia Sumergida: San Francisco Javier de Batuc, la pérdida de una hoya architectónica colonial*. Hermosillo, Sonora: Imagen Digital del Noroeste.

Engelhardt, Zephryin. 1899. *The Franciscans in Arizona*. Harbor Springs, MI: Holy Childhood Indian School.

Fontana, Bernard L. 1983. "Nuestra Señora de Valvanera in the Southwest." In *Hispanic Arts and Ethnohistory in the Southwest*, edited by Marta Weigle, 81–92. Santa Fe, NM: Ancient City Press.

Fontana, Bernard L. 1996. "The Handwriting on the Wall." In *The Pimería Alta: Missions and More*, edited by James E. Officer, Mardith Scheutz-Miller, and Bernard L. Fontana, 72. Tucson, AZ: The Southwestern Mission Research Center.

Fontana, Bernard L. 2010. *A Gift of Angels: The Art of Mission San Xavier del Bac*. Photographs by Edward McCain. Tucson: the University of Arizona Press.

Forbes, Robert H. 1952. *Crabb's Filibustering Expedition into Sonora, 1857*. Tucson: Arizona Silhouettes.

Fuentes Yañez, Jesús. 1991. *Correrías Apaches en Nácori Chico*. Hermosillo: Instituto Sonorense de Cultura.

Griffith, James S. 1983. "Kachinas and Masking." In *Handbook of North American Indians*, edited by William C. Sturtevant, vol. 10, *The Southwest*, edited by Alfonso Ortiz, 764–77. Washington, DC: Smithsonian Institution.

Griffith, James S. 1992. *Beliefs and Holy Places: A Spiritual Geography of the Pimería Alta*. Tucson: University of Arizona Press.

Griffith, James S. 1995. *A Shared Space: Folklife in the Arizona-Sonora Borderlands*. Logan: Utah State University Press.

Griffith, James S. 2000. *Saints of the Southwest*. Tucson, AZ: Rio Nuevo Publishers.

Griffith, James S. 2002. *Heroes and Horses: Corridos from the Arizona-Sonora Borderlands*. Smithsonian Folkways Recordings SFW 40475. Washington DC: Smithsonian Institution.

Griffith, James S. 2003. *Folk Saints of the Borderlands: Victims, Bandits, and Healers*. Tucson, AZ: Rio Nuevo.

Griffith, James S. 2005. "Voices from Inside a Black Snake: Religious Monuments of Sonora's Highways." *Journal of the Southwest* 47 (2): 233–48.

Griffith, James, and Francisco Manzo Taylor. 2006. "Voices from Inside a Black Snake, Part II: Sonoran Roadside Chapels." *Journal of the Southwest* 48 (3): 233–59.

Griffith, James, and Francisco Manzo Taylor. 2007. *The Face of Christ in Sonora / El rostro del Señor en Sonora*. Tucson, AZ: Rio Nuevo.

Hernández Salomón, Manuel. 2007. *Navojoa: Cronología y Testimonios II, 1915–1935*. Navojoa: El Colegio de Sonora.

Kasl, Ronda, ed. 2009. *Sacred Spain: Art and Belief in the Spanish World*. Indianapolis, IN: Indianapolis Museum of Art.

Kelly, Sean, and Rosemary Rogers. 1993. *Saints Preserve Us! Everything You Need to Know About Every Saint You'll Ever Need*. New York: Random House.

Lamadrid, Enrique. 2002. "Santiago and San Acacio: Slaughter and Deliverance in the Foundational Legends of Colonial and Postcolonial New Mexico." *Journal of American Folklore* 115 (457): 457–74.

Lizárraga García, Benjamín. 1996. *Templo de San Diego del Pitiquí: Documentos para la historia*. Hermosillo: Gobierno del Estado de Sonora.

Manzo Taylor, Francisco. n.d.a "De cómo llegaron los 'santos' (imagines religiosas) a Sonora." Unpublished manuscript in possession of the author.

Manzo Taylor, Francisco. n.d.b "La mujer en la cultura, un olvido imperdonable." Unpublished manuscript in possession of the author.

McGarvin, Thomas C. 1987. "The 1887 Sonoran Earthquake: It Wasn't Our Fault." *Fieldnotes of the Arizona Bureau of Geology and Mineral Technology* 17 (2): 1–2.

Montoya López, Sigifredo. 2005. "Leyendas de Huépac." In *Crónicas, leyendas, fiestas y tradiciones: Lo nuestro de los municipios de Sonora*, edited by José Luís Barragán Martínez, 85–88. Hermosillo, Sonora: Editorial Garabatos.

Morfi, Juan Agustín de. 1967. *Diario y Derrotero (1777–1781)*. Monterrey, Nuevo León: Instituto Tecnológico y De Estudios Superiores de Monterrey.

Naylor, Thomas H. 1977. "Massacre at San Pedro de la Cueva: The Significance of Pancho Villa's Disastrous Sonora Campaign." *Western History Quarterly* 8 (2): 125–50.

Oktavec, Eileen. 1995. *Answered Prayers: Miracles and Milagros Along the Border*. Tucson: University of Arizona Press.

Officer, James E., Mardith Scheutz-Miller, and Bernard L. Fontana, eds. 1996. *The Pimería Alta: Missions and More*. Tucson, AZ: The Southwestern Mission Research Center.

Panofsky, Erwin. 1955. *Meaning in the Visual Arts*. Garden City, NY: Doubleday.

Perry, Frances Burke. n.d. *Saved by Faith and Fire*. Comic book. Provo, UT: Perry Enterprises.

Pickins, Buford, ed. 1993. *The Missions of Northern Sonora: A 1935 Field Documentation*. Tucson: University of Arizona Press.

Pineda Pablos, Nicolás. 2003. *Río Abajo: Crónicas de la familia Pablos y otros parentescos del sur de Sonora*. Hermosillo, Sonora: Editorial Garabatos.

Quinn, Robert. n.d. "The Spanish Colonial Missions of Baja California." Unpublished typescript in possession of the author.

Ramírez Domínguez, Miguel Darío. 2008. "Por qué Nuestra Señora del Rosario." In *Crónicas, leyendas, fiestas y tradiciones*, edited by Barragán Martinez, 135–36. Hermosillo, Sonora: Editorial Garabatos.

Redondo, Margaret Procter. 1993. "Valley of Iron: One Family's History of Madera Canyon." *Journal of Arizona History*, Autumn, 223–73.

Roca, Paul M. 1967. *Paths of the Padres Through Sonora*. Tucson: Arizona Pioneers' Historical Society.

Salazar Gudiño, Zoíla. 2005. "Leyenda de San Miguel Arcángel." In *Crónicas, leyendas, fiestas y tradiciones: Lo nuestro de los municipios de Sonora*, edited by José Luís Barragán Martínez, 67–68. Hermosillo, Sonora: Editorial Garabatos.

Sandoval, Annette. 1997. *The Directory of Saints: A Concise Guide to Patron Saints*. New York: Signet.

Santini de Vanegas, Gloria Elena. 2002. "The Wandering Baby Jesus." *SMRC Revista* 36 (133): 19.

Scheutz-Miller, Mardith K. 2000. "Survival of Early Christian Symbolism in Monastic Churches of New Spain and Visions of the Millennial Kingdom." *Journal of the Southwest* 42 (4): 763–800.

Simmons, Marc. 1991. "Santiago: Reality and Myth." In *Santiago: Saint of Two Worlds*, edited by Marc Simmons, Donna Pierce, and Joan Myers, 1–29. Albuquerque: University of New Mexico Press.

Spicer, Edward H. 1962. *Cycles of Conquest: The Impact of Spain, Mexico, and the United States on the Indians of the Southwest 1533–1960*. Tucson: University of Arizona Press.

Steele, Thomas J. 1974. *Santos and Saints: Essays and Handbook*. Albuquerque: Calvin Horn.

Sweeney, Edwin R. 1991. *Cochise: Chiricahua Apache Chief*. Norman: University of Oklahoma Press.

Sweeney, Edwin R. 2010. *From Cochise to Geronimo: The Chiricahua Apaches, 1874–1886*. Norman: University of Oklahoma Press.

Taylor, William B. 2016. *Theater of a Thousand Wonders: A History of Miraculous Images and Shrines in New Spain*. New York: Cambridge University Press.

Thurston, Herbert, and Donald Attwater, eds. 1963. *Butler's Lives of the Saints, Complete Edition*, by Alban Butler. New York: P. J. Kennedy.

Treviño Guerrero, Andrea Isabel. 2010. "Chapo Charo." In *La revolución Mexicana: Hechos y personajes de Sonora*, Asociación de Cronistas Sonorenses, 142–45. Hermosillo: Instituto Sonorense de Cultura.

Tucson Parks and Recreation Department. 1982. *Garden of Gethsemane, Felix Lucero Park*. Tucson, AZ: City of Tucson Parks and Recreation Department.

Valles Septien, Carmen. 1994. *La Ruta de los santuarios en México*. Mexico City: CVS Publicaciones.

Vanderwood, Paul J. 1998. *The Power of God Against the Guns of Government: Religious Upheaval in Mexico at the Turn of the Nineteenth Century*. Stanford, CA: Stanford University Press.

Vaughan, Mary Kay. 1997. *Cultural Politics in Revolution: Teachers, Peasants, and Schools in Mexico, 1930–1940*. Tucson: University of Arizona Press.

Vernon, Edward W. 2002. *Las Misiones Antiguas: The Spanish Missions of Baja California, 1683–1855*. Santa Barbara CA: Viejo Press.

West, Robert C. 1993. *Sonora: Its Geographical Personality*. Austin: University of Texas Press.

Weisman, Alan, with photographs by Jay Dusard. 1988. "Arizona's Shrine of St. Joseph." *Arizona Highways* 64 (8): 33–37.

Wilson, William A. 2006. "Freeways, Parking Lots, and Ice Cream Stands: Three Nephites in Contemporary Mormon Culture." In *The Marrow of Human Experience: Essays on Folklore*, 243. Logan: Utah State University Press.

Wroth, William. 1982. *Christian Images in Hispanic New Mexico: The Taylor Museum Collection of Santos*. Colorado Springs: The Taylor Museum of the Colorado Springs Fine Arts Center.

INDEX

Note: Page numbers in *italics* refer to illustrations.

Academia Nacional de Arte (Mexico City), 56

Aconchi, 8–9, *10*, 76

Aduana, 35–36, *37*, 76, *110*, 123

Afligidos, Señor de los, 56, 121

Agua Prieta, 47, *49*

Águila, Luz Aguilar, 53–54, *55*

Álamos, *105*, 106–7

Alejo, San (Saint Alexis), 82, 126

altars (home), 9, *10*, 90, 93, 95, *96*, 97, 101

Altar Valley, 5, *14*, 84, 135

angels, *27*, *45*, 97, 123–24, 126, 131

Angulo F., Carlos. *See* Carlitos

Antonio, San (Saint Anthony), 6, 17, *82*, 87, 90–91, 126, 135–36

Anza, Juan Bautista de, 19

Apaches, 16, 39, 63, 87, 134–36, 140, 142

Apocalypse, Virgin of the, 19, *20*

Araiza, Beatriz, 53, *54*

Arizona, *2*, 65, 82–84, 100; missions in, 16–17, 63; religious art in, 16–17, 19, 63; Sonorans in, 39; Yaqui ceremonies in, 21–22. *See also* San Xavier del Bac Mission

Arrastradito, 83–84, 132

artists, 4, 10; local, 26–27, 38, 79, 93, 97; Mexico-trained, 28, 53, 56; self-taught, 58–59, *60*, 61; women, 52–53, *54*, *55*. *See also* workshops

Asúnsolo, Ignacio, 56

Átil, *17*, 84–85, 132

Ávila, Josefina, 53

Bacanora, *106*, 107

Bácerac, 32, *34*, 35, 76, 107, 134

Bacoachi, 135–36, 141

Balbanera, Nuestra Señora de (Virgin of Balbanera), 35–36, *37*, 76, *110*, 111, 123

Barbara, Santa (Saint Barbara), 119, 126–27

baroque style, 6, *8*, 22, 28–29, 32, *33*, 56, *82*, 92, 112

Battle of Clavijo, 87, 131, 141

Batuc, 59, *60*

Black Christ. *See* Cristo Negro

Buen Retiro, Señor de, 107, *109*

bultos de vestir, *26*, *30*, *31*, 123

Butler's Lives of the Saints, 82

Caborca, *111*, 112, 133–34, 141–42

Calles, Pedro, 54, 56, *57*, 58

Calles, Rodolfo Elías, 40

Cananea, 53, 65, 141

Candelaria, Virgen de la (Virgin of Candlemas), 38, 103, *104*, 123

Carlitos, 85, *86*, 87, 131

155

Carrillo, Charlie, 90–91

Catholic Church, 47, 65, 116; on sacramental art, 88–89; on sainthood, 77–78, 81–84, 87; wealth and power of, 38–39

Catholicism, 131; and religious art, 19, 39–40, 91–92, 94, 116; and shrines, 51; in Sonora, 3–4, 10, 16, 38–41, 99; in Spain, 141–42

Cayetano, San (Saint Cajetan), 63–64, 82–83, 127

Cecilia, Santa (Saint Cecilia), 59, *60*, 127

chapels, 85, 94, 100–101, 107, 132; destruction of, 103–4; of *narcotraficantes*, 61, *62*; private, 38, 56, *57*; as roadside shrines, 3, 41, *43*, 46, *47–50*, 51, 61, *62*, 74

Charo, el Chapo, 84–87, 132

Christ, *10*, *34*, 46, 56, 77, 90, 98–99, 121–22. *See also* Cristo Negro; crucifixes

Christ Child, 25, 95, *113*, 122–25. *See also* Niño de Atocha, Santo; Niño de Caborca, Santo; Niño de Praga, Santo

communities, definition of, 3–4

Compostela, Santiago de (Saint James the Greater), 87, 91, 131, 141–44

Contreras Castillo, Manuel Edgardo, 112

Contreras, Francisco, 112

corridos (folk songs), 141, 145

Council of Trent, 94

Crabb, Henry Alexander, 133–34

cristiada, la, 39–40, 98

Cristo Negro (Black Christ), 141

Cristo Negro de Aconchi (Black Christ of Aconchi), 8–9, *10*, 76, 90, 103

cronistas (chroniclers), 86–87, 141

crucifixes, *17*, 35, *92*; of Cristo Negro (Black Christ), 8–9, *10*, 90, 141;

description of, 121–22; and Easter ceremonies, 20–21, 140–41; at El Molinote, 107, *109*

Culiacán, Sinaloa, 49, 132

Diego, San (Saint Didacus), *75*, 127

Dismas, San (Saint Dismas), 77, 127

Dolorosa, Virgen (Sorrowing Virgin), 21–22, *23*, 31, 94, 123

Durango, 72, 140–41

Easter ceremonies, 20–22, 31, 92, 122, 140

Eduvigis, Santa (Saint Hedwig), *57*

El Molinote, 107, *109*

El Oasis, 46, *47*, 74, 94

Entierro de Bácerac, Santo (Holy Sepulcher of Bácerac), *34*, 35, 76, 122

Esperanza, Virgen de (Virgin of Hope), *117*

Espinazo, Nuevo León, 84, 132

espiritus, 84–87, 89, 131

Esquipulas, Nuestro Señor de, 8, 90, 121

estofado, 28, *29*, 95, *96*, *104*

ex-votos, *34*, 78–79, *80*, 91, 131

Fátima, Our Lady of, 46, *47*, 74, 94, 123

Fidencio, el Niño, 84, 132

folklorists: fieldwork of, 10–12, 40, 95, 97; role of, 3–4, 9–10, 116

Fontana, Bernard, 11–12

Franciscans, 6, 17, 19, 26, 124–27

Francisco Borja, San (Saint Francis Borgia), 107, *108*, 128

Francisco Javier, San (Saint Francis Xavier), 127–28; fiesta for, 65, *66*, 67, *68–71*; statue of (del Bac), *18*, *30*, *31*; statue of (Magdalena), 24, 40, 65, *66*, 67, 94, 98, 100–101, *102*, 115

Fronteras, 95, *96*, 136

Gadsden Purchase, 39, 90, 121

Garcés, Father, 19

García, Jesús, 11–12

Garden of Gethsemane (Felix Lucero Park), 59

Geronimo, 134, 136

Gil, Etelnidora, *104*

Gonzales, Alfredo, 11–12

Guadalajara, 28, 35

Guadalupe, Virgen de (Virgin of Guadalupe), 47, 123–24; paintings of, 28–29, 53–54, *55*, 59, *106*; roadside shrines for, *44–46*, *49*, 51, 61, 74, 79, *80*

Guaymas, 100

Hacienda Cerro Pelón, 38

Hacienda de los Tepehuanes, 103–4

Hermosillo, *27*, 53–54, *55*, 56, 85, *86*, 100, 131

Highway 15, 11, *27*, 43, 46, *48*, 59, 61, 79, *80*, *81*

Holy Trinity, *27*, 121, 127

Huachinera, 135, 139, 141

Huásabas, *15*, *80*

Huépec, 87, 135, 137, *138*, 141

iconoclastic movements, 98. See also *persecución, la*

Ignacio Loyola, San (Saint Ignatius Loyola), 124, 128, 136, *137*, 139

Immaculate Conception, *105*, 106, 125, 134

Ímuris, 12, *46*, 59, 61, 72, 90, 109–10, 121

Iniqui, María Emilia Fontes, 53

Isidro Labrador, San (Saint Isidore the Husbandman), *15*, *57*, 97–98, 131

Italian devotional art, 91, 124

Javier del Vigge Mission, 32

Jécori, *117*

Jesuits, 5, 7, 16–17, 25–26, *27*, 32, 65, 124, 128

Jorge, San (Saint George), 119, 128

José, San (Saint Joseph), *29*, 81, 128, 142

Juan Bautista, San (Saint John the Baptist), *103*, 128–29

Juan Evangelista, San (Saint John the Evangelist), 21–22, *23*, 129

Judas Tadeo, San (Saint Judas Thaddeus), 44, *46*, 47, 49, 51, 129

Kino, Eusebio Francisco, 16, *17*, 100

La Labor, 9, *10*, 76

Lázaro, San (Saint Lazarus), 72, 129

León, Anastacio "Tacho," 72, *73*, 76, 93

Lorenzo, San (Saint Lawrence), 87, 137, *138*

Loreto, Virgen de (Our Lady of Loreto), 25, *26*, 31, 124

Lucero, Felix, *58*, 59

Lucía, Santa (Saint Lucy), 22, *24*, 29, *80*, 81, 129

Luz, Virgen de la (Virgin of Light), 124

Magdalena, *50*, 97–98; religious fiesta in, 65, *66*, 67, *68–71*, 72, *73*, 74; San Francisco statue in, 24, 40, *66*, 76, 94, 100–101, *102*

Malverde, Jesús, *49*, *50*, 132

Manzo, Francisco "Paco," 11–12, 24, 49, *80*, 86–87

Mapimí, Señor de, 140–41

María Magdalena, Santa (Saint Mary Magdalen), 21–22, *24–26*, 129

Martín Caballero, San (Saint Martin the Horseman), 61, *62*, 129–30

Martín de Porres, San (Saint Martin of Porres), *102*, 130

Mátape (Villa Pesqueira), 7, 89

Maycoba, 107, *108*

Mayo Indians, 21–22, 67, *68*, 92, 102, *103*, 140

Mexico: independence of, 38–39, 125; revolution of, 38–39, 84, 86, 135

Mexico City, 28, 32, 35, 53, 56, 72

milagros, 22, 79, *80*, *109*, *110*, *138*

Milagrosa, Virgen (Virgin of Miracles), 53, *54*, 122–23

miracles, 34–35, 77–79, 91, 93, 95, 102, 130, 140

mission churches, 5, 144; founding of, 16–17; patron saints of, 7, 17, 87; and

religious art, 16–17, 19, 32, 36. *See also specific churches*

Moctezuma, 32, *33*, 44

Molina, Epifanio, *46*, 59, 61

Molina, Sergio, *46*, 61

Moors, 87, 122, 131, 141, 144

Mormons, 143

Moya, José, 67, 72–73

Muerte, Santa (Saint Death), *48*, 132

murals: didactic, 19, *20*, 92; restoration of, *63*; roadside, 3, 41, 59, *60*, 61, *62*, 76, 79

Nácori Chico, 134–35, 141

Nácori Grande, 7, *8*, 24, *25*, *26*, 31, 59, *60*, 89, 115

narcotraficantes, 47, *48*, 49, *50*, 51, 61–62, 132

Native Americans, 16, 65, 142. *See also specific tribes*

Navarrete, Francisco, 100

Navarrete, Juan, 53, 100

neoplatonism, 89

New Mexico, 51, 82–83, 90, 114, 121, 142

Niño de Atocha, Santo (Holy Infant of Atocha), 11, 79, *81*, 122

Niño de Caborca, Santo (Holy Infant of Caborca), *111*, 112

Niño de Praga, Santo (Holy Infant of Prague), 122

Nogales, 65–67, 145

Nuestra Señora de la Asunción Church, 34

Nuestra Señora de la Purísma Concepción Church, 134

Nuri, 94–95, 135, 138

Ocotlán, 94

offerings, 3, 42–43, 47–48, 78–79, 84–85, *86*, 91, 94

O'odham Indians, 16, 72, *92*, 101, 134

Opodepe, 83–84, 112, 132, 139–42

Oquitoa, 53, 85, 87, 132, 135–36, 141–42

Orozco, Pascual, 135

Pacheco, Juan, 102–3

Pafnuncio, San (Saint Paphnutius), *83*, 130

paintings, 3, 17, *37*, 59, 93, 125; colonial-era, 28–29, 32; legends about, 35–36, 97–98; rescue of, *106*, 107; by women artists, 53, *54*, *55*. *See also* ex-votos; murals; restoration: of paintings; retablos

Papago Indians, 5–6, 101, 135

patria chica, la, 144–45

Pedro, San (Saint Peter), 107, 130, 142

persecución, la: accounts of, 98–116; art hidden during, 94–95, 107, *108*, *109*; art rescued during, 76, *104–106*, *110*, 111–12, *113*; explanation of, 40, 99

Pieta, *58*

pilgrims/pilgrimages, 72, 78, *81*, 121–22; and El Niño Fidencio, 84, 132; and religious fiestas, 35, 65–67, 76; and San Francisco statue, *66*, 76, 94, 100–101, 115

Pimería Alta, 16, 100, 128

Pitiquito Church, 19, *20*, 22, *23*, *29*, 92

Pope, the, 77, 130

Portugal, 38, 46, 123

prints, 35, 100

Protestants, 51, 98

Pueblo de Álamos, 135–37, 141

Puerto Peñasco, 112, *113*, 114

quemasantos (saint burners), 116; art destroyed by, 9, 24, 40, 100–101, 111; art rescued from, 9, 105, *106*, 110–11, *117*

Quintero, Rafael Caro, 61

Ramón Nonato, San (Saint Raymond the Unborn), 89, 91, 130–31

Rayón, 107, 112

Refugio de Pecadores, Virgen de (Virgin of Refuge), 125

Reina, Rafael. *See* Charo, el Chapo

religious art, 4–5; in America, 54; brought to Sonora, 16–17, 28, 30, 32, *33*, 35–36, 38, 118; destruction of, 9, 24, 40, 76, 99, 100–103, 111; interactions with, 3, 10, 67, 76; legends about, 7, 9–10, 32, 34–36, 89–90; localized versions of, *15*; ordering of, 36, 38, 46, 53; restoration of, *17*, 73, 116; role of, 10, 17, 19–22, 28, 88–98, 114–16; verbal, 119–20. *See also* roadside shrines; *and specific types*

religious dramas, 20–22, 140–41

religious fiestas, 39–40, 61, *75*; description of, 65–67, 74; and religious art, 9–10, *18*, 22, 35, 64, 76, 95, 107, 111, 114; for the Virgin, 47, 94–95, 114, 123. *See also* Magdalena: religious fiesta in

Remedios, Virgen de los (Virgin of Los Remedios), 7, *8*, 89, 115, 123, 125

restoration: of paintings, 35–36, *37*, 63, 97–98, *106*, 116; of statues, *17*, 22, 56, 63–64, 73, 76, 90, 93, 112, *113*, 116

retablos, 27, 31–32, *33*, 53

roadside shrines, 3, 11, 40, 91, 124; death crosses as, 3, 41–43; of *narcotraficantes*, 47, *48–50*, 51, 61–62, 132; purpose of, 41–44, 47, 51, 61; rock piles as, 41, *42*. *See also* chapels: as roadside shrines; Guadalupe, Virgen de (Virgin of Guadalupe): roadside shrines for; murals: roadside

Ropy (artist), 59, *60*, 61, 76

Rosa de Lima, Santa (Saint Rose of Lima), 95, *96*, 130–31, 134

Rosario, Virgen del (Our Lady of the Rosary), 94–95, 107, 112, *113*, 114, 125, 135

sacramental art, 88–89

sacristan/sacristana, 11, 89–90, 119

sainthood, 77–78, 81–84, 100

Saint Joseph the Carpenter, Shrine of, *58*, 59

saints, 47, 49, 77; descriptions of, 126–31; fiestas for, 65, 74, *75*, 76; "folk," 82–84, 132; legends about, 5–7, 9, 11, 79, *80*, *81*, 84–87, 90–91; rescue villages/villagers, 6, 11, 78, 131, 133–45; role of, 17, 78, 81–83, 87; and their images, 3, 88–91, 93; as "victim intercessors," 84–87. *See also specific art forms; specific names*

San Acacio (Colorado), 142

San Antonio de Oquitoa: church of, *5*, 6; village of, 5–6, 17

San Ignacio de Cabórica Church, 22, *24*, 29, 89–90

San Ignacio de Cuquiárachic Church, 135–36, *137*, 141

San Javier Church, 26, *27*

San Miguel Arcángel (Archangel Michael), 126, 136, 138, *139*

San Pedro village, 54, 56, *103*

Santa Ana Viejo, 11, 79, *81*

Santa Rosa de Lima Church, 95, *96*, 134

Santuario de Guadalupe Church, 53–54, *55*

San Xavier del Bac Mission, 16, 27, *30*, *31*, 32, 34, 39, 63, *82*, 94, 98, 100

Seri Indians, 5–6, 16, 135

Sinaloa, 16, 49, 72, 132

socialism, 9, 39–40, 116

Soledad, Virgen de (Sorrowing Virgin statue), 35, 125

Sonora, Mexico: anticlerical policies in, 9, 39–40; geography of, 10, 12–13, *14*, 15–16; legends about, 5–7; map of, *2*; period of conflict in, 39–40, 98–99, 115–16; religious piety of, 3–4

Spain, 122, 124; and Balbanera devotion, 36, 123; and Mexican devotional art, 91, 94; and the Saints, 87, 127–28,

131, 141–42, 144. *See also* Battle of Clavijo

statues, 6, 54, 115–16; of cement, 58–59; on church facades, 26, *27*; clothing for, 3, 25, 28, 30, 93–94, 111, 114; destruction of, 9, 100–103, 107; legends about, 32, 34–36, 40, 90–91, 93–95, 100–103, *110*, 123, 134; making of, 26–29; of plaster, 36, 38, 76; recycling of, 22, *23–26*; rescue of, 9, 103, *104*, 105, 109, *110*, 111–12; transported by mule, 7, 30, 32, 35, 125; of wood, 25, 32, 36, 38, 121. *See also* restoration: of statues; *and specific artists; specific saints*

Tabasco, 142

Tánori Contreras, Jesús, 9

Tánori Dórame, Julia, 9, *10*

Tónichi, 41, *42*

Trincheras, 61–62

Tubutama Church, *27*, 32

Tucson, Arizona, 4, 11, 19, 58–59, 66, 90, 100, 121

Tumacácori National Historic Park, 16, 63–64

Ures, 53, *54*, 56, 135, 138, *139*, 141

Valdéz, Guadalupe, *110*, 111

Vasconcelos, José, 13

Villa, Francisco "Pancho," 54, 56, 84, 132, 143

Villa Pesqueira, 56, *57*

Virgin Mary, *44*, 93–94, 112, 122–26, 134–35, 142, 144. *See also* religious fiestas: for the Virgin; *and specific names*

Winkelman-Hayden, Arizona, 93

workshops, 12, 22, 28, 30

Yañez Cemetery, 85, *86*, 131

Yaqui Indians, 5–6, 21–22, 44, *45*, 67, 92, 124, 135–37, 140

Yarnell, Arizona, *58*, 59

Zapópan, 125–26

ABOUT THE AUTHOR

James S. Griffith is the former director of the Southwest Folk-lore Center at the University of Arizona. He earned his PhD in cultural anthropology and art history from the University of Arizona. He has authored three books published by the University of Arizona Press: *Beliefs and Holy Places: A Spiritual Geography of the Pimería Alta* (1993), *Hecho a Mano: The Traditional Arts of Tucson's Mexican American Community* (2000), and *Southern Arizona Folk Arts* (1988). He is also the author of four books published by Rio Nuevo Publishers: *A Border Runs Through It: Journeys in Regional History and Folklore* (2011), *The Face of Christ in Sonora* (2007), *Folk Saints of the Borderlands: Victims, Bandits, and Healers* (2003), and *Saints of the Southwest* (2000). Griffith founded the folklife festival Tucson Meet Yourself in 1974. He has been honored for his distinguished service to folklore and the state of Arizona with awards such as the 2005 Henry Glassie Award and the 2009 Pima County Library Lifetime Achievement Award. He was named a National Heritage Fellow by the National Endowment for the Arts in 2011.

THE SOUTHWEST CENTER SERIES

Joseph C. Wilder, Editor

Ignaz Pfefferkorn, *Sonora: A Description of the Province*
Carl Lumholtz, *New Trails in Mexico*
Buford Pickens, *The Missions of Northern Sonora: A 1935 Field Documentation*
Gary Paul Nabhan, editor, *Counting Sheep: Twenty Ways of Seeing Desert Bighorn*
Eileen Oktavec, *Answered Prayers: Miracles and Milagros Along the Border*
Curtis M. Hinsley and David R. Wilcox, editors, *Frank Hamilton Cushing and the Hemenway Southwestern Archaeological Expedition, 1886–1889*, volume 1: *The Southwest in the American Imagination: The Writings of Sylvester Baxter, 1881–1899*
Lawrence J. Taylor and Maeve Hickey, *The Road to Mexico*
Donna J. Guy and Thomas E. Sheridan, editors, *Contested Ground: Comparative Frontiers on the Northern and Southern Edges of the Spanish Empire*
Julian D. Hayden, *The Sierra Pinacate*
Paul S. Martin, David Yetman, Mark Fishbein, Phil Jenkins, Thomas R. Van Devender, and Rebecca K. Wilson, editors, *Gentry's Rio Mayo Plants: The Tropical Deciduous Forest and Environs of Northwest Mexico*
W. J. McGee, *Trails to Tiburón: The 1894 and 1895 Field Diaries of W J McGee*, transcribed by Hazel McFeely Fontana, annotated and with an introduction by Bernard L. Fontana
Richard Stephen Felger, *Flora of the Gran Desierto and Río Colorado of Northwestern Mexico*

Donald Bahr, editor, *O'odham Creation and Related Events: As Told to Ruth Benedict in 1927 in Prose, Oratory, and Song by the Pimas William Blackwater, Thomas Vanyiko, Clara Ahiel, William Stevens, Oliver Wellington, and Kisto*

Dan L. Fischer, *Early Southwest Ornithologists, 1528–1900*

Thomas Bowen, editor, *Backcountry Pilot: Flying Adventures with Ike Russell*

Federico José María Ronstadt, *Borderman: Memoirs of Federico José María Ronstadt, edited by Edward F. Ronstadt*

Curtis M. Hinsley and David R. Wilcox, editors, *Frank Hamilton Cushing and the Hemenway Southwestern Archaeological Expedition, 1886–1889*, volume 2: *The Lost Itinerary of Frank Hamilton Cushing*

Neil Goodwin, *Like a Brother: Grenville Goodwin's Apache Years, 1928–1939*

Katherine G. Morrissey and Kirsten Jensen, editors, *Picturing Arizona: The Photographic Record of the 1930s*

Bill Broyles and Michael Berman, *Sunshot: Peril and Wonder in the Gran Desierto*

David W. Lazaroff, Philip C. Rosen, and Charles H. Lowe, Jr., *Amphibians, Reptiles, and Their Habitats at Sabino Canyon*

David Yetman, *The Organ Pipe Cactus*

Gloria Fraser Giffords, *Sanctuaries of Earth, Stone, and Light: The Churches of Northern New Spain, 1530–1821*

David Yetman, *The Great Cacti: Ethnobotany and Biogeography*

John Messina, *Álamos, Sonora: Architecture and Urbanism in the Dry Tropics*

Laura L. Cummings, *Pachucas and Pachucos in Tucson: Situated Border Lives*

Bernard L. Fontana and Edward McCain, *A Gift of Angels: The Art of Mission San Xavier del Bac*

David A. Yetman, *The Ópatas: In Search of a Sonoran People*

Julian D. Hayden, *Field Man: The Life of a Desert Archaeologist*, edited by Bill Broyles and Diane Boyer

Bill Broyles, Gayle Harrison Hartmann, Thomas E. Sheridan, Gary Paul Nabhan, and Mary Charlotte Thurtle, *Last Water on the Devil's Highway: A Cultural and Natural History of Tinajas Altas*

Thomas E. Sheridan, *Arizona: A History, Revised Edition*

Richard S. Felger and Benjamin Theodore Wilder, *Plant Life of a Desert Archipelago: Flora of the Sonoran Islands in the Gulf of California*

David Burkhalter, *Baja California Missions: In the Footsteps of the Padres*

Guillermo Núñez Noriega, *Just Between Us: An Ethnography of Male Identity and Intimacy in Rural Communities of Northern Mexico*

Cathy Moser Marlett, *Shells on a Desert Shore: Mollusks in the Seri World*

Rebecca A. Carte, *Capturing the Landscapes of New Spain: Baltasar Obregón and the 1564 Ibarra Expedition*

Gary Paul Nabhan, editor, *Ethnobiology for the Future: Linking Cultural and Ecological Diversity*

James S. Griffith, *Saints, Statues, and Stories: A Folklorist Looks at the Religious Art of Sonora*